perspective
drawing

PRENTICE-HALL, INC., Englewood Cliffs, New Jersey 07632

Jane H. James

West Valley College
Saratoga, California

perspective drawing
A DIRECTED STUDY

Library of Congress Cataloging in Publication Data

JAMES, JANE H.
 Perspective drawing.

 1. Perspective. 2. Drawing—Technique.
I. Title.
NC750.J25 742 80-13386
ISBN 0-13-660357-2

Editorial/production supervision by Joan L. Lee
Interior and cover design by Judith Winthrop
Manufacturing buyer: Harry P. Baisley
Drawings by Jane H. James
Photos by Jane H. James
 William H. James
 Steve Peltz
 Paul Dileanis

Printed in the United States of America

10 9 8 7 6 5 4 3 2 1

PRENTICE-HALL INTERNATIONAL, INC., *London*
PRENTICE-HALL OF AUSTRALIA PTY. LIMITED, *Sydney*
PRENTICE-HALL OF CANADA, LTD., *Toronto*
PRENTICE-HALL OF INDIA PRIVATE LIMITED, *New Delhi*
PRENTICE-HALL OF JAPAN, INC., *Tokyo*
PRENTICE-HALL OF SOUTHEAST ASIA PTE. LTD., *Singapore*
WHITEHALL BOOKS LIMITED, *Wellington, New Zealand*

My deepest gratitude is extended to Dr. Darryl Sink and his production staff at West Valley College, Saratoga, California, for their advice, encouragement, and technical assistance; to the many students whose drawing problems prompted the writing of this book; and to the friends and family who edited, made suggestions, and field-tested it—especially to Ann Rinehart, Holly Vossoughi, Lee Roy Pipkin, Ann Marie Mix, Ruth Schauss, Karen Calcagno, Carol Charney, Steve Peltz, and Paul Dileanis. A very special thank you to my husband, William H. James, for his help, encouragement, and tolerance during times of total preoccupation with the work.

contents

viii

preface

Perception is uniquely personal, and its communication is an intimate gift of self, a gift that defines and characterizes the human species. Drawing is the oldest recorded means of this communication and probably is the clearest and most personal, even among today's multiplicity of sophisticated visual communications. Perspective drawing is certainly not new; its history and the formulation of its rules are very well documented, and its use in Western culture is clearly understood. Although many drawing purposes do not require perspective, it is a very important option, and its study provides an enriching means of perceiving the world.

Perspective Drawing: A Directed Study is intended to acquaint the reader with the basic principles of perspective drawing and to provide practice in using them; it is designed to be a self-paced learning tool. Anyone interested in representational drawing will easily grasp the initial concepts in each chapter; photos and drawings bridge the gap between the visual experience of living in a three-dimensional world and representing that world on a two-dimensional surface. Each chapter starts with basic concepts and self-tests with answers; as more concepts are applied, the complexity increases. In this way each reader can proceed as far as is appropriate in each chapter. A study of the complete book may be used as a basic course for aspiring artists and interior designers who need a thorough grounding in the principles of perspective and enough practice to make the concepts a part of their permanent knowledge; or the book may be used as a reference by artists who understand the basics of perspective but who occasionally run across a perplexing problem. Chapter 8, "Exact Proportioning and Scale Drawing," will be particularly useful for this purpose.

This book requires very simple tools and materials: a pencil (number 2 or HB) and a means of keeping it sharp, a pencil eraser, and paper. A pad of white ledger or bond paper 11 by 14 inches or larger will do very nicely. In addition you will want an 18-inch ruler, and a plastic triangle (8 inches; 45 degrees) will be a time saver. Two or three colored pencils will be helpful for construction lines. As your skills and perception increase, you can discard mechanical aids for freehand drawing, or you can acquire more sophisticated tools for precision work; but a quality of exactness is important in the beginning to help you better understand the principles. Later, if you use tools only rarely, they can easily be improvised: a sheet from your pad of paper will serve as a straightedge, and its corner will serve in place of a triangle. If you are working on paper with irregular edges, you can always get a straight edge by folding any scrap of paper on a flat surface; folding it a second time so that the edges meet exactly makes a square corner. In place of a ruler, folding a thin piece of paper will give you equal segments. A word of warning: If paper tools are used more than occasionally, they are apt to become limp or ragged and serve no purpose of exactness.

Perspective drawing can be an intellectual game in which the parts fit together like a puzzle according to a set of rules, or it can be used as a group of principles that enhance understanding and expression of forms in space. The creative artist chooses to use it, distort it, or ignore it on the basis of what it can contribute to the spirit and purpose of the work at hand.

The rules of perspective should be your tool, not your master.

perspective
drawing

1
an
introduction

WHAT IS PERSPECTIVE?

The word *perspective* has various definitions: viewpoint; point of view; the point from which you view; one view of the world. Perspective is one of many useful approaches to drawing. Its principles underlie the representation of distance in the visual world and the placement of shapes in distance. Most freehand drawing is done by eye, but it may help your eye if you understand the underlying principles of perspective drawing.

We use our sight to help us move around in our three-dimensional world, and through it we receive a constantly changing series of views of spatial relationships—that is, objects as they relate to each other in space. But in most drawings we are capturing a *single* view from a *particular* place and are using perspective to create the illusion of three dimensions on a two-dimensional surface—one view of the world.

Knowledge of perspective is as important to the artist as knowledge of drawing tools and materials. Only when perspective is understood do you have the choice of whether to use it, when to use it, and what kind of perspective or perspective distortion best serves your expressive purpose.

In a broad sense, *perspective* means any creation of a three-dimensional illusion on a two-dimensional surface. To many people this term means *linear perspective*, which is what this book is about; however, there are many other kinds of perspective as well, which can be used singly or combined to enhance the perspective effect. Here are some you will recognize.

TYPES OF PERSPECTIVE

Overlapping

When one form partially hides another, it is in front of the other—closer to us—implying distance, or a spatial relationship. This relationship is called overlapping. The forms might be touching, or there might be miles between them, but we know that the one in front is closer. Overlapping is particularly useful in suggesting shallow space or very little distance between forms, as in overlapping pieces of paper or cards on a table where there are few if any other clues to distance. However, overlapping is also used to express deep space—as when you see one mountain range overlapping another—or in middle distance when you see buildings, trees, cars, and people overlapping.

Figure 1-1

Modeling or Shading

A gradual change from dark to light around a form, as another way of showing depth or three-dimensional quality, is called modeling or shading. Modeling is useful in showing the distance between the front and the back of a rounded form. Look at this piece of fruit. Without its modeled shadow, it might be a flat circle instead of a sphere—quite a difference in three-dimensional quality!

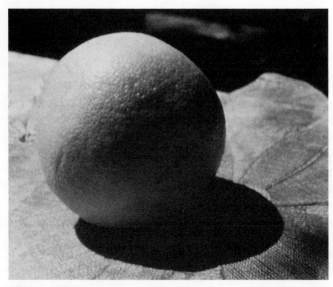

Figure 1-2

Color Perspective

The relative warmth and coolness of two or more colors produce color perspective. Generally, warm colors are those associated with warm physical experiences: yellow, orange, and red are associated with sun and fire, and we speak of them as being "warmer" than blue, violet, and green, which are associated with water, grass, and shadows. We may sometimes speak of a "cool" red, however, meaning a red-violet, as compared to a "warm" red in the red-orange range. Or we might speak of a "warm" blue (blue-green) compared to a "cool" blue (blue-violet). So the "warmth" or "coolness" of a color depends on what color it is next to or compared with. The intensity (brightness) and the value (dark or light) also affect color perspective, but given equal intensity and value, the *warmer color will seem to advance* toward you, the *cooler color to recede.* In many abstract or nonobjective paintings, this factor is extremely important in manipulating space. Color perspective does not, of course, apply to black and white drawings, but it is unavoidable when drawing with any colored medium. Look at the cover of this book. Are the arrows pointing right or left?

They are pointing both ways, of course, but most people first see the arrows pointing left because they are a warmer, more advancing color. The arrows pointing right are seen as background because they are a cooler color.

Aerial Perspective

This perspective is especially useful in expressing deep space—far distance.

Figure 1-3

Aerial perspective is based on the observation that atmosphere, particularly air close to the earth, contains particles of dust and moisture that tend to obscure vision. This effect is obvious in smog or fog but is also easy to see on a clear day. With distance, *clarity of detail* diminishes, *color intensity* diminishes, and *value contrast* diminishes. Things seem to become fuzzy and gray toward the horizon.

Linear Perspective

Probably the most easily recognized and best known means of expressing distance is linear perspective. It is based on the observation that the appearance of *size* diminishes with distance. It is called *linear* because one of the easiest ways to measure or judge diminishing size is by observing the diminishing distance between receding parallel lines. This book will be concerned with the basic principles of linear perspective.

Figure 1-4

1. Perspective drawing enables us to represent three dimensions on a two-dimensional surface. (True or False)
2. Correct perspective is always necessary in good drawing. (True or False)

Match each type of perspective with its key idea.

3. *Overlapping*
4. *Modeling or shading*
5. *Color perspective*
6. *Aerial perspective*
7. *Linear perspective*

A. *warm colors advance*
B. *decreasing size*
C. *gradual dark to light*
D. *one shape in front of another*
E. *decreasing contrast*

Answers: 1. True; 2. False; 3. D; 4. C; 5. A; 6. E; 7. B

9

2
linear perspective

This book shows you how to handle any linear perspective drawing problem you are likely to encounter.

DIMINISHING SIZE

If you are ever confused, remember that diminishing *size* is the key idea. *Distance makes a difference! The farther away an object is, the smaller it appears.*

Try this experiment: Put your hand in front of your face. How much of your view does it cover: an entire house, a wall, a table? Now move your hand back about a foot from your face. How much does it cover? You know your hand is not as big as a desk or a wall. Extend your arm fully. How much smaller your hand now seems compared to objects near you! Objects at close range appear much larger than they appear at a distance, and the farther away they are, the smaller they seem, until they disappear from view. To judge this ever-diminishing size, let us consider two parallel lines always the same distance apart. The distance between them, which could be marked by rungs on a ladder or ties between railroad tracks, seems to diminish as it recedes into the distance until it disappears and finally vanishes at a vanishing point. The same might be true of a fence. We seldom see either of these examples, however; railroad tracks and fences have a way of turning corners or disappearing behind hills or buildings or trees. But, when they *do* continue *straight, flat,* and *unhidden,* those two parallel lines seem to converge, or meet, *at a vanishing point on the horizon line, which is your eye level.*

The following pages will explain these terms more fully.

EYE LEVEL

The eye level is the position where your eyes are located (physically) in relation to the subject viewed. If a level horizontal line were drawn through your eyes, where would it seem to be on your subject? This is the eye level.

Try this experiment: Hold a pencil in front of your eyes and look around the room. Keep it parallel to the floor. This is where your eye level is in the room as long as you remain seated. Now stand up. See how your eye level has changed?

Figure 2–1 shows a table.

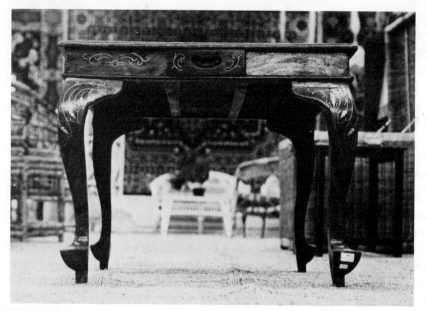

Figure 2-1

Lying on the floor might give you this view because your eyes are below the top of the table (figure 2–1).

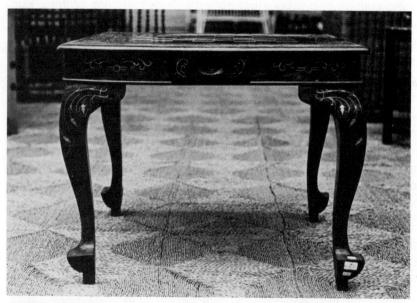

Figure 2-2

If you sit up, your eyes are on a higher level—above the top—and you might see this view (figure 2–2).

14

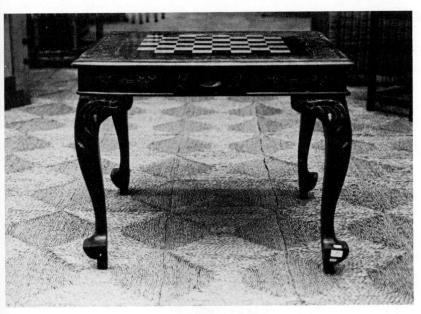

Figure 2-3

If you sit on a chair, your eyes are even higher, and you might see this view (figure 2–3).

If you look up or down without moving your head, your eye level is unchanged. It is only when the location of your eyes changes in distance from the floor that your eye level changes. When you are looking at a photo or a drawing, you are seeing the subject from the eye level of the camera or the artist.

Look at this shelf. Is the camera's eye above it or below it? Can you see the underneath side? If you can, the eye level is below it.

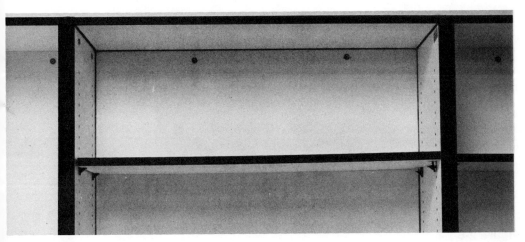

Figure 2-4

HORIZON LINE

The horizon is the place where the earth and sky seem to meet. This is always a straight level line, and is most easily seen on flat land where there are no mountains, buildings, or trees in the way, or where a large body of calm water and the sky seem to meet. It should not be confused with the irregular profile of mountains, buildings, or trees seen against the sky. Remember that the horizon line is where *level* land or water would be seen against the sky. In figure 2–5, where is the horizon line? (The answer is figure 2–8).

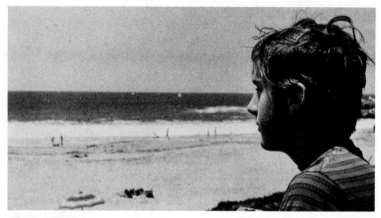

Figure 2-5

The horizon line is the same as your eye level because the height of your eye level determines where you will see the horizon. If you are close to level land or water, you will see very little of the earth compared to the amount of sky you can see. This is called a *low eye level* (fig. 2–6).

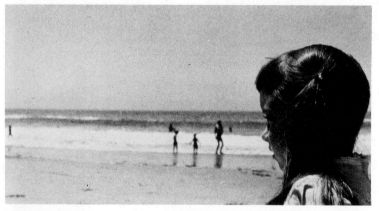

Figure 2-6

If you are high above level land or water, you can see much more of the earth compared to the amount of sky you can see. This is called a *high eye level* (fig. 2–7). But no matter where you are, your eye level is always on the horizon line; they are one and the same.

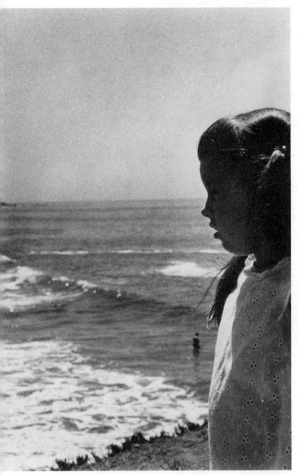

Figure 2-7

On each of the following photos (figs. 2–9 and 2–10) draw the eye level (horizon line) and label it high or low eye level. (Answers are figures 2–13 and 2–14.)

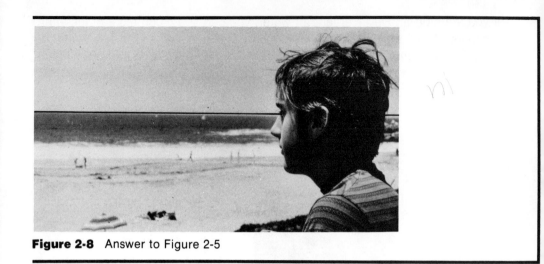

Figure 2-8 Answer to Figure 2-5

Low eye level. You are on the road. This is flat land; therefore the eye level (horizon line) is where earth and sky meet. You see more sky than earth.

Figure 2-9

High eye level. You are on a high bank above the river and can see the tops of trees on both sides of the river; so your eye level (horizon line) is above them. However, beyond the trees the land rises in a gentle hill just a little higher than where you are standing; therefore your eye level (horizon line) is a little below the top of the hill. You see more earth than sky.

Figure 2-10

REMEMBER:

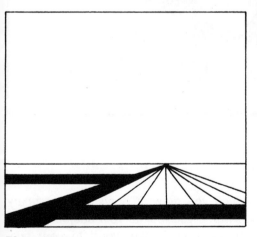

Figure 2-11
LOW EYE LEVEL.
You are on ground level.
Ground compressed.

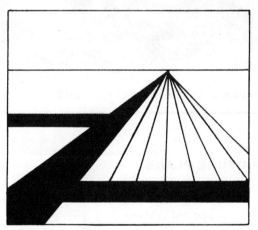

Figure 2-12
HIGH EYE LEVEL.
You are high above ground level.
Ground expanded.

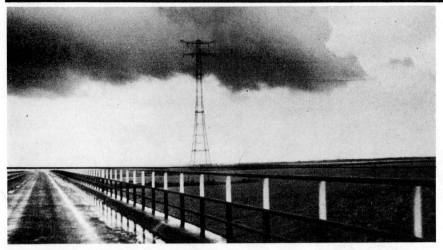

Figure 2-13 Answer to Figure 2-9

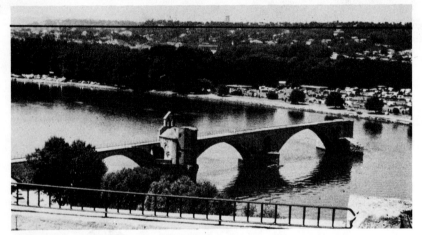

Figure 2-14 Answer to Figure 2-10

PICTURE PLANE

The picture plane is the surface on which you draw; it is also an imaginary vertical surface, like a window, through which you look at your subject. In this way, you translate your three-dimensional view of the world to your two-dimensional surface. Sit in front of a window, holding your head very still. Trace directly on the glass with a grease pencil the outlines of the objects you see on the other side.

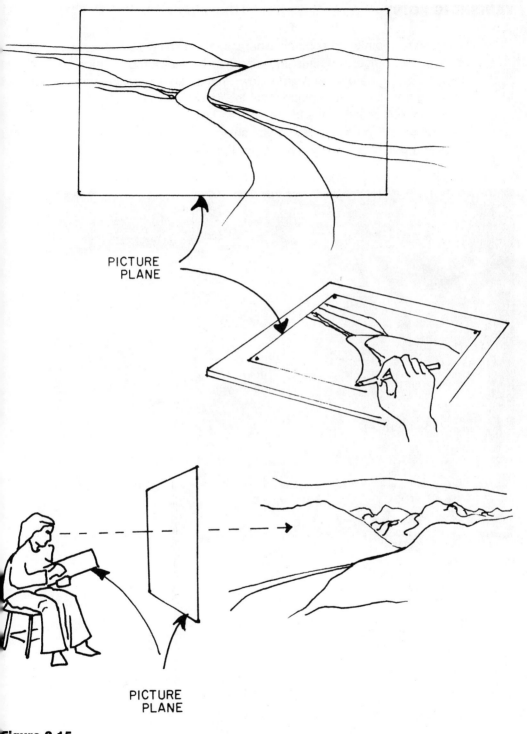

PICTURE
PLANE

PICTURE
PLANE

Figure 2-15

VANISHING POINT

A vanishing point is the place where a diminishing size disappears on the horizon line. Since a diminishing size can be measured by receding parallel lines, as in the railroad tracks, it follows that all lines parallel to each other and receding from the picture plane go to the same vanishing point. In these photos trace all the receding lines to the horizon line (eye level). Any lines parallel to each other will go to the same vanishing point. Label horizon line (HL) and vanishing point (VP). (The answers are figures 2–19, 2–20, and 2–21.)

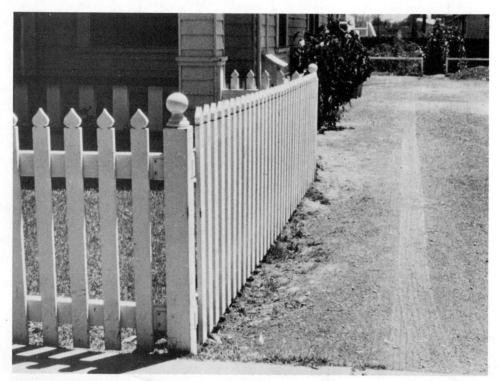

Figure 2-16

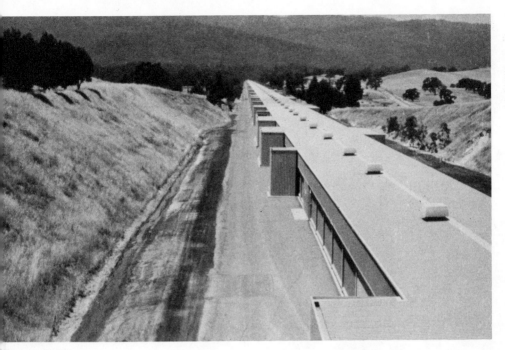

Figure 2-17

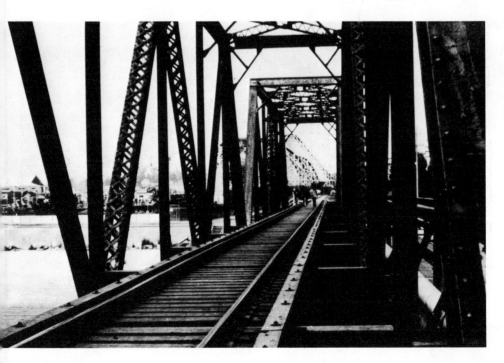

Figure 2-18

23

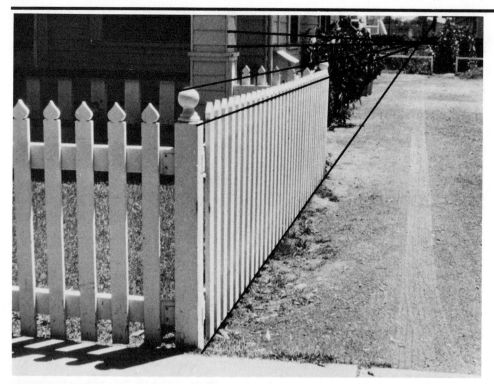

Figure 2-19 Answer to Figure 2-16

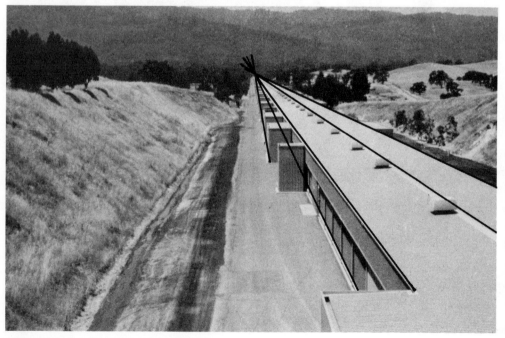

Figure 2-20 Answer to Figure 2-17

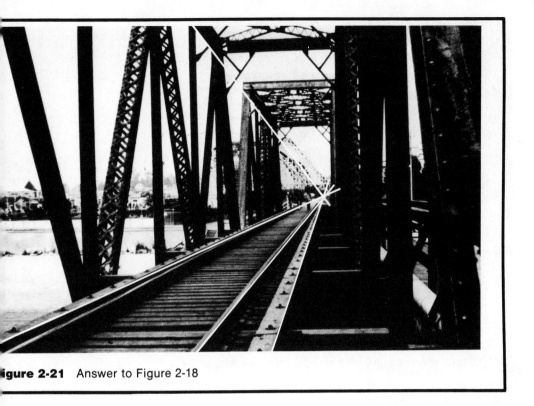

Figure 2-21 Answer to Figure 2-18

ONE-, TWO-, AND THREE-POINT PERSPECTIVE

Perhaps you have heard of one-point perspective, two-point perspective, and three-point perspective. These perspectives simply mean different ways of viewing a three-dimensional object. If only one of the three dimensions (the depth) is receding from the picture plane, there will be only one vanishing point, and we have one-point (1-pt.) perspective. If two dimensions are receding (depth and width), there will be two vanishing points, one for each dimension, and we have two-point (2 pt.) perspective. If all three dimensions are receding (depth, width, and height), there will be three vanishing points, one for each dimension, and we will have three-point (3-pt.) perspective.

One-Point Perspective

In one-point perspective, only the depth is receding from the picture plane. Consider this box; its opposite surfaces are parallel to each other and so are the edges of those surfaces.

132483

Figure 2-22

From this view the height is parallel to the picture plane (that is, the edge of the paper); therefore the height is not receding and that dimension will not have a vanishing point. On this box there are four height edges—although we see only two. Here the width is parallel to the picture plane; it is likewise not receding, and therefore the width dimension will not have a vanishing point either. There are four width edges on this box. Here we see three.

In this case there will be a 90-degree angle or square corner between the height and width edges.

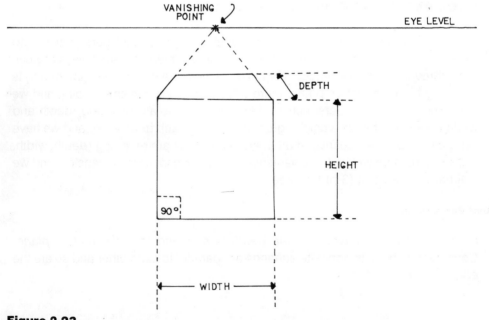

Figure 2-23
ONE-POINT PERSPECTIVE

If your eye level is above the top of the box you can see the top. Here the depth dimension is *not* parallel to the picture plane. This top surface is going back in space, receding from the picture plane. If this depth continued instead of stopping at the back edge of the box, it would eventually disappear at a vanishing point on the eye level. This vanishing point is directly in front of where you are standing.

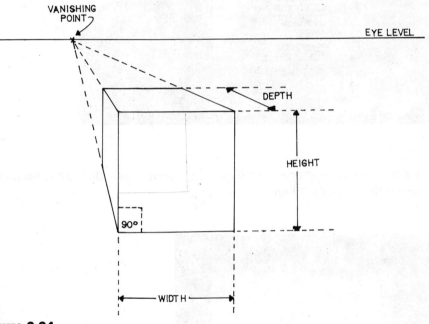

Figure 2-24
ONE-POINT PERSPECTIVE

If you were not standing directly in front of the box as in figure 2–24, you might see some of its side depth dimension as well as the top. It could still be in one-point perspective if there is a 90-degree angle (a right angle) forming a square corner between the height and width, both of which are parallel to the picture plane (the edges of your paper).

You are seeing this box, then, in one-point perspective because only one of its three dimensions is receding from the picture plane.

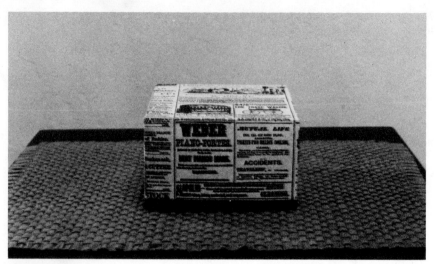

Figure 2-25

Here is a photo of a box in one point (fig. 2–25). Draw it. Include the eye level and vanishing point and label them.

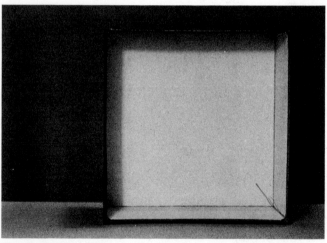

Figure 2-26

Here is a photo of another box in one-point perspective (fig. 2–26). You cannot see the receding top, only the edge of it, because the top is exactly on the eye level; nor can you see the receding side on the left. Only its edge is visible, because that side crosses the vanishing point directly in front of you. It is useful to remember: *A receding plane (or surface) is seen as an edge (or straight line) only when it is on the eye level or when it or its extension crosses the vanishing point* (fig. 2–27).

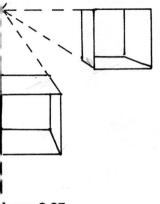

igure 2-27

Mark the vanishing point (VP) in figure 2–26.

igure 2-28

Here is a group of boxes in one-point perspective (fig. 2–28). Draw the group showing eye level and vanishing point.

Remember that *all lines (or edges) parallel to each other and receding from the picture plane go to the same vanishing point.*

When you have finished, turn to figure 2–29 to check your result. For more practice with one-point perspective, draw a page of boxes, some of them open.

29

Figure 2-29 Answer to Figure 2-28

Two-Point Perspective

Here is another view of a box. The height is parallel to the picture plane (n
receding), so will have no vanishing point.

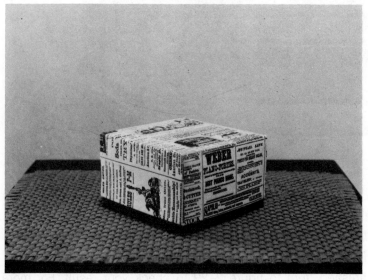

Figure 2-30

The depth, however, is not parallel to the picture plane. It is receding toward a vanishing point on the eye level. The width also is not parallel to the picture plane, and it is receding toward its vanishing point on the *same* eye level.

You are seeing this box in two-point perspective because two of its three dimensions are receding from the picture plane.

Each of these dimensions has its own vanishing point, but both points are on the same eye level since there can be only one eye level for any single view.

Draw the box in two-point perspective.

1. Start with the leading edge (the edge closest to you). It is the vertical *height* edge of the box. Add the eye level and vanishing points, keeping them far apart.
2. Next, the *width*, the front left side, top and bottom edges receding toward the left vanishing point and ending at the left height edge.
3. Now draw the depth, the front right side, top and bottom edges receding toward the right vanishing point and ending at the right height edge.
4. Now show the back *depth* edge. It goes from the *left* height edge to the *right* vanishing point.
5. Finally, add the back *width* edge—from the *right* height edge to the *left* vanishing point.

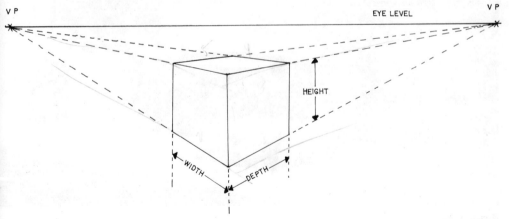

Figure 2-31
TWO-POINT PERSPECTIVE

Some of the edges of this box (fig. 2–31) are hidden, but if it were glass yo would see all four edges for each dimension. All four *width* edges recede to th *left* vanishing point and all four *depth* edges recede to the *right* vanishing poin because *all lines parallel to each other and receding from the picture plane go t the same vanishing point.*

Here is a group of boxes in two-point perspective. Draw them. Include eye leve and vanishing points. When you have finished, check your drawing with figur 2–35.

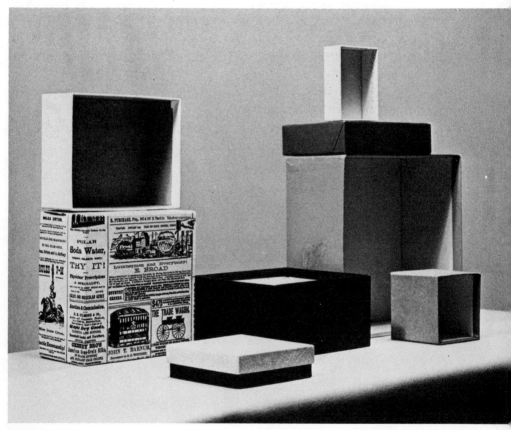

Figure 2-32

Draw the eye level on each of the following two photos. Label each *1 pt.* or *2 p* (Refer to figures 2–36 and 2–37 for answers.) For more practice with two-poir perspective, draw a page of boxes, some of them open. Show dotted lines for a hidden edges.

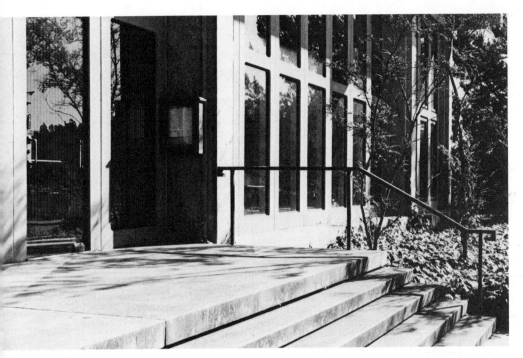

Figure 2-33

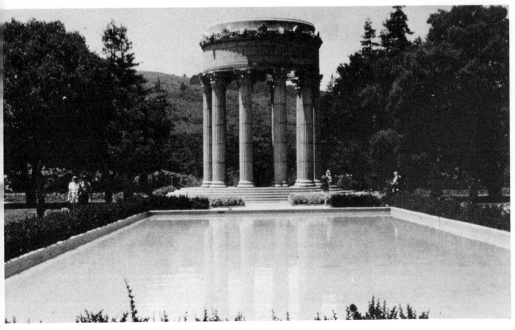

Figure 2-34

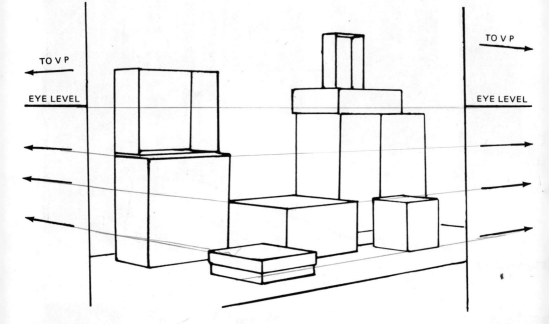

TO V P

TO V P

EYE LEVEL

EYE LEVEL

Figure 2-35 Answer to Figure 2-32
TWO-POINT PERSPECTIVE

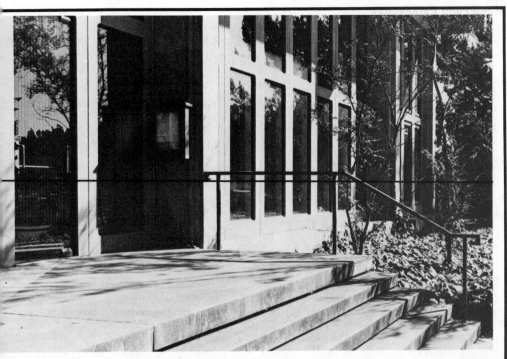

Figure 2-36 Answer to Figure 2-33
E-POINT PERSPECTIVE

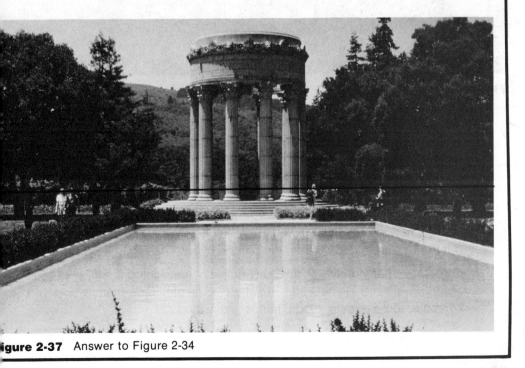

Figure 2-37 Answer to Figure 2-34

What happens if the box is tilted? The depth is receding to its vanishing point. The width is receding to its vanishing point.

Figure 2-38

But now the height is also receding to a third vanishing point. *When the height dimension recedes, its vanishing point will be either directly above or directly below the eye level vanishing point* that would otherwise govern it—how far above or below depends on the steepness and direction of the slant. This is why three-point perspective is called *the perspective of the slanted plane.*

You are now seeing this box in three-point perspective because all three of its dimensions are receding from the picture plane.

Three-point perspective, or the perspective of the slanted plane, applies to any receding slanted plane—that is, where a height dimension is involved: for example, roofs, streets, roads, ramps, stairways.

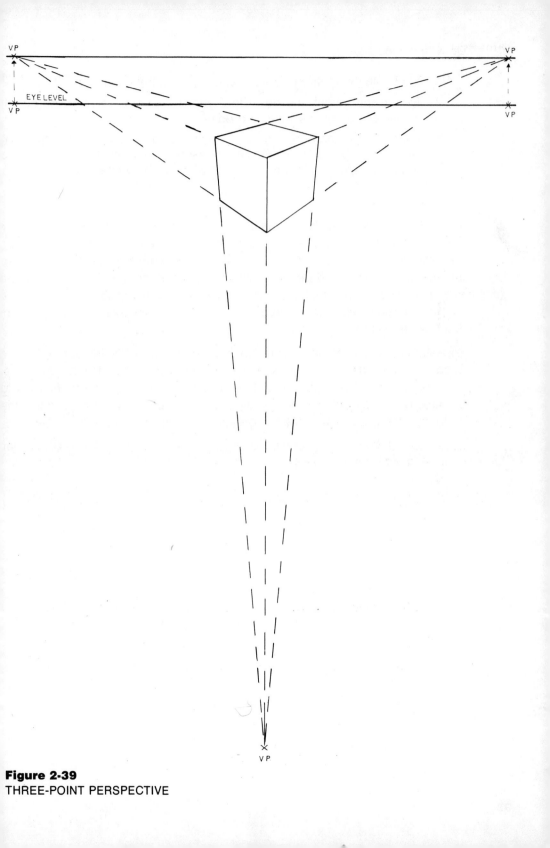

VP

EYE LEVEL

VP

VP

VP

VP

Figure 2-39
THREE-POINT PERSPECTIVE

Draw this tilted box.

1. Start with the corner closest to you—the top front corner.
2. Extend the height line down to a vanishing point below it. All height edges will go to this vanishing point.
3. Locate width and depth vanishing points on a horizontal above the box. All depth edges go to the vanishing point on the right; all width edges go to the vanishing point on the left. The box is complete.

You will notice that when the box is tilted, all three of its dimensions recede from the picture plane; one corner is closer than any of the others. Therefore the top and bottom surfaces are slanted planes, as are the width and depth surfaces. For this reason the width and depth vanishing points are on a horizontal above the eye level used for the level table underneath. All three vanishing points for the box are now considered to be three-point vanishing points because all planes of this box are slanted.

Sometimes only one plane (or surface) of a form is slanted, for example, when a building is seen in two-point perspective and has a slanted roof. In this instance, only the roof would be in three-point perspective, and its vanishing point would be directly above or below the eye level vanishing point used for the rest of the building. This case is explained in greater detail in chapter 4.

Locate the vanishing point for each slanted plane shown here (fig. 2–40). (Refer to figure 2–41 for the answers.)

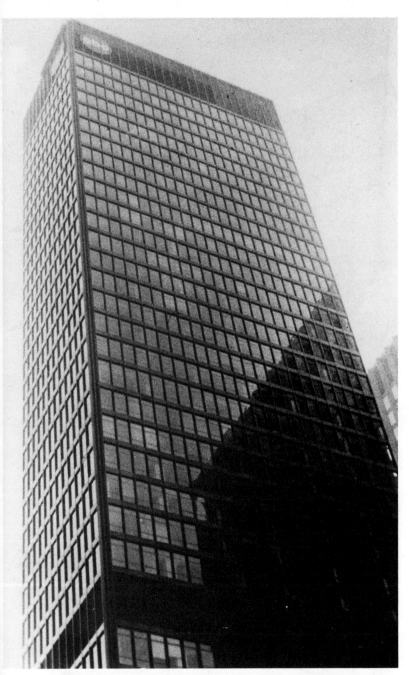

Figure 2-40

You have now drawn in one-point, two-point, and three-point perspective. Your further studies of perspective will be built on this knowledge.

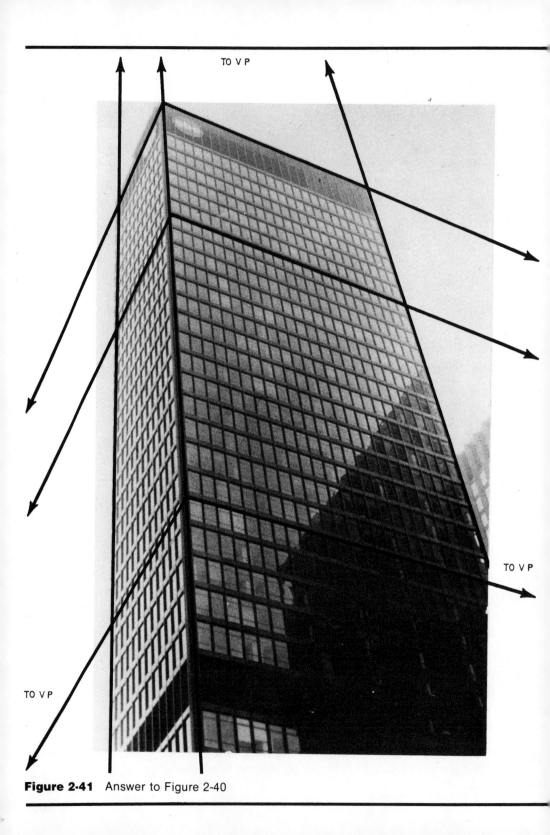

TO V P

TO V P

TO V P

TO V P

Figure 2-41 Answer to Figure 2-40

SOME GENERAL CONSIDERATIONS

1. Using Mechanical Aids

There are many ways to draw in perspective, and each serves a particular purpose. Quite precise and mechanical means are often necessary for such things as architectural drawing, interior design, product design, and advertising. After a building has been constructed or a product manufactured, photography is often used to show it; but in the design phase, accurate drawing is essential. It is also sometimes necessary to use mechanical means to verify the accuracy of freehand drawing.

In freehand drawing, the objective is a convincing approximation of the appearance of things rather than the precise accuracy obtained with drafting tools; however, when straight lines are needed, don't hesitate to use a ruler. If you want to develop skill in drawing freehand straight lines, practice without a ruler, remembering to keep your eye on where the line is going, not where it has been. Try this: Place two dots anywhere on your paper. Place the pencil on one but keep your eye on the other. Draw the line between them carefully and steadily, but not too slowly. Check your accuracy with a ruler.

2. Perspective as a Means of Expression

In drawing and painting, the use of perspective enables a convincing representation of the real world, and it operates as an effective means of expression as well.

One-point perspective conveys a feeling of formality and stability. This quality of frontal confrontation can command respect or awe (fig. 2–42).

Figure 2-42

Two-point perspective is more dynamic, more active, more exciting. Its angular lines are more apt to gain the attention of the viewer. For this reason, two-point perspective is used more than one-point perspective in modern advertising and illustration (fig. 2–43).

Figure 2-43

Three-point perspective can be even more dynamic and is often used to emphasize or exaggerate size or distance (fig. 2–44).

Figure 2-44

It is possible to carry any of these to an extreme that defeats the purpose of believable representation.

3. To Avoid Unwanted Distortion

In One-Point Perspective, place the vanishing point well within the central area of the drawing.

In Two-Point Perspective, place the vanishing points far apart, with at least one of them outside the drawing.

In Three-Point Perspective, keep the drawing within the triangle formed by the three vanishing points.

Remember, you cannot draw an object beyond the vanishing point because it will have vanished from your view.

4. Diminishing Perspective Effect

In general, the perspective effect of linear perspective diminishes with distance. In other words, linear perspective is more obvious in objects close to you than in those same objects viewed at a distance.

3

dividing
space

3

NONRECEDING SPACE: MEASUREMENT

We often need to be able to divide space seen in perspective. Nonreceding space can, of course, be divided by measurement, but it may be necessary to divide a solid receding surface into equal parts, or perhaps to evenly space objects receding into the distance.

RECEDING SPACE

Diagonals Used for Dividing in Half

Limited Space Here is one good method: Suppose the box in two point is a trunk and you need to find the center of its receding side in order to place the latch. This is a fairly simple matter:

1. First, draw the trunk as a closed box in two-point perspective below eye level.
2. To find the center of the long side, draw diagonals to its opposite corners. The point at which they cross is the center of that side.
3. Draw a vertical through that point. Next draw the latch on this vertical where the lid overlaps the front of the trunk.
4. Now suppose a handle is centered on the end of the trunk. Again, diagonals drawn to opposite corners will determine the center.
5. Draw the handle.

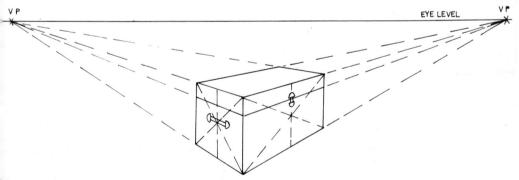

Figure 3-1

6. Now suppose the trunk has two straps. To locate them, divide each half of the front into half again by drawing diagonals, then draw verticals from the center points. These are the strap centers.
7. The straps will also go across the lid to the vanishing point used for the top. The trunk is complete.

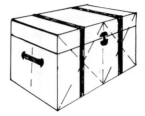

Figure 3-2

Any receding rectangle can be divided in half and each part into half again as many times as you wish by *using diagonals to find the center.* This process *gives an even number of equal divisions in a limited space.*

Unlimited Vertical Space Suppose you want to draw a barbed wire fence receding into the distance. The diagonal method can work here too if all the posts are in fact the same height and the same distance apart (see fig. 3–3).

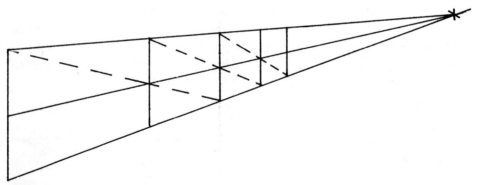

Figure 3-3

1. Start with the eye level and a vanishing point (VP), then draw the first post well below eye level.
2. Now draw a line from the top of this post to the VP. The top of each post will be on this line.
3. Draw a line from the bottom of the first post to the VP. This is the ground line. The bottom of each post will be on this line.
4. Find the center of the first post by measuring it, and draw a line from this center point to the VP. The center of each post will be on this line.
5. Next, draw the second post at whatever distance looks right. This establishes the distance between all the posts.

6. Now draw a diagonal from the top of the first post through the center of the second post and continue it to the ground line. This locates the base of the third post.

7. Another diagonal from the top of the second through the middle of the third shows where the fourth is planted.

8. Continue as far as you like.

9. To finish the fence, erase top, bottom, center, and diagonal lines. Add the wire.

Equally spaced divisions receding in unlimited space can be found with diagonals.

Unlimited Horizontal Space This method also is used for horizontal surfaces, as in drawing a sidewalk. In many amateur drawings sidewalks look like they are standing on end or on edge. Follow this procedure to make a sidewalk appear flat (see fig. 3–4).

1. Draw the eye level and vanishing point (VP). Make this one-point perspective.

2. Next, draw two lines representing the two edges of the sidewalk going back to the VP.

3. Draw another line exactly between them to the VP.

4. Now, draw the first horizontal, crossing all three lines at the bottom.

5. Add the second horizontal as far back as you think it should be.

6. (This next step is similar to a fence lying flat on the ground.) A diagonal from one end of the first line through the middle of the second line shows you where the third line should go.

7. Continue as far as you like.

Figure 3-4

In two-point perspective the procedure is the same except that the cross divisions go to the second vanishing point. Try it. To establish the center line, put in the first two cross lines, then diagonals from opposite corners. Proceed as before and continue as far as you wish.

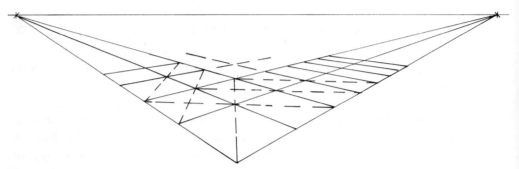

Figure 3-5

This method can also be used to draw a checkerboard (eight squares by eight squares), a tile floor or counter, tile on a receding wall, or a series of columns, arches, or telephone poles. See chapter 8 for precise calculation of the receding depth.

Projection

Suppose you have limited receding space and an uneven number of divisions, or irregular spacing on a receding surface. If so, here is another method you can use (see fig. 3–6):

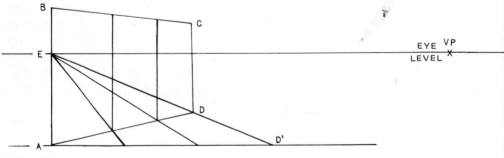

Figure 3-6

Odd-Numbered Divisions

1. Draw a receding wall and label the corners *A, B, C,* and *D.*
2. Show the eye level and vanishing point.
3. Draw a horizontal through *A.*
4. Point *E* is where *AB* crosses the eye level. Draw the diagonal *ED* and extend it through the horizontal to *D.*
5. The line *AD*[1] is a nonreceding view of the line *AD*, so it can be divided by measurement into any uneven number, or it can be used to locate irregularly spaced doors and windows.
6. Divide the line *AD*[1] into three equal segments (by measurement).
7. Now draw a line from each of these points to *E.* At the points where these lines cross *AD*, erect verticals. The receding plane *ABCD* is now divided into three equal parts.

Irregular Spacings　Now try the projection method for some irregular spacings on the wall (see fig. 3–7).

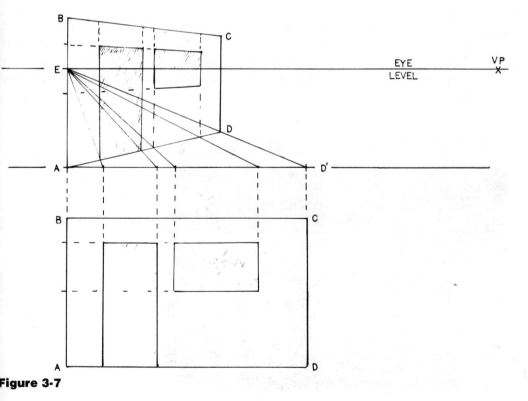

Figure 3-7

1. Draw a nonreceding view of wall *ABCD* with a door and window.
2. Somewhere above it, draw a horizontal.
3. Directly above *AB*, on the horizontal, draw the vertical *AB* the same size.
4. Locate D^1 on the horizontal directly above *C*.
5. Locate the door and window on AD^1.
6. Now draw the eye level crossing *AB* above the horizontal and a vanishing point (VP) somewhere on it.
7. Next draw the diagonal ED^1.
8. The lower edge of the receding wall goes from *A* to the VP and crosses ED^1 locating the corner *D*.
9. A line from *B* to the VP forms the top of the wall, establishing point *C*.
10. *ABCD* above the line is now the receding view of *ABCD* below the line.
11. Connect the door and window division points on AD^1 to *E*.
12. Erect verticals where the points cross. The door and the window are now located vertically.
13. Their horizontal placement can be found by transferring their height measurements from the lower *AB* to the upper *AB* and going from these points to the VP.

Using the methods just learned, draw this storefront as a receding wall. You will need an additional VP left of point *E* in order to draw the bay, overhang, and beams. Take all divisions to the wall of the building, then project divisions for the bay, beams, and overhang from the left VP forward. The door may be partly hidden by the bay.

Figure 3-8

Here is an example of an architectural drawing in perspective using the projection method.

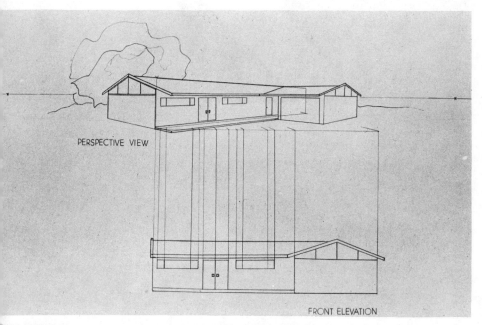

PERSPECTIVE VIEW

FRONT ELEVATION

Figure 3-9
PERSPECTIVE VIEW
FRONT ELEVATION

4

the slanted plane

4

Chapter 2 refers to three-point perspective as the "perspective of the slanted plane" because it is used when the height dimension is receding, thereby creating a slanted plane. The three-point vanishing point (3-pt. VP) for that slanted plane will be either directly above or directly below the eye level vanishing point (VP) it would have if it were flat (level). How far above or below the eye level VP depends on the *steepness* of the slant. If the slant is very steep, the 3-pt. VP will be far above or below the eye level VP; if the slant is not very steep, the 3-pt. VP will not be very far above or below eye level VP. The *direction* of the slant determines whether the 3-pt. VP is above or below the eye level VP. If the slant is going down as it recedes, the 3-pt. VP will be below the eye level VP. If the slant is going up as it recedes, the 3-pt. VP will be above the eye level VP. Figure 4–1 contains some slanted planes. Can you find them and their vanishing points? Figure 4–2 shows where they are.

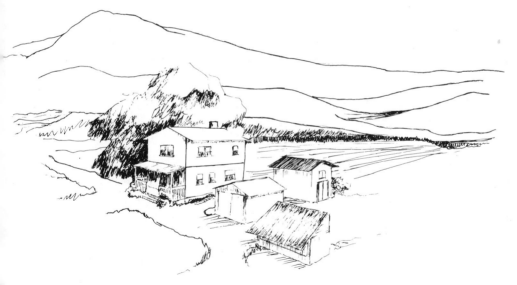

Figure 4-1

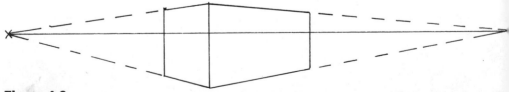

Figure 4-2 Answer to Figure 4-1

USING THE SLANTED PLANE VANISHING POINT FOR CONSTRUCTION

Roofs

When drawing a building with a slanted roof, the receding dimensions of th building recede toward eye level vanishing points, but the ascending roof plan recedes toward a slanted plane vanishing point directly above the eye leve vanishing point. In this case the slanted plane vanishing point is often used t help construct the roof.

Roof on a Two-Point Perspective Building To see how this works, draw simple building in two-point perspective and add a slanted roof. Here are th steps to follow:

Figure 4-3

1. Start with the eye level a little above center on your paper with vanishing points (VPs) near the edges.
2. If you are standing on the same ground level as the shed, your eye level will be at about two-thirds of the wall height. The closest height edge is first, crossing the eye level with about one-third of it above eye level.
3. Extend receding horizontals to the VPs at top and bottom on both sides.
4. Draw a vertical height line to limit each side. Now you have a simple rectangular building without a roof.

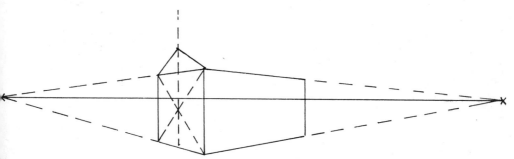

Figure 4-4

5. To add the roof, find the center of one side by using diagonals.
6. Then extend a vertical upward from the center above the top of the wall. The peak of the roof will be on this line. The higher it is, the steeper the roof will be.
7. Next, establish the peak and connect it with the two top corners at the end of the building.

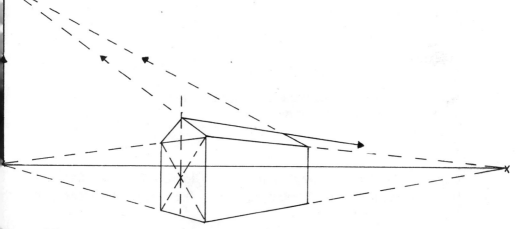

Figure 4-5

8. The roof ridge is parallel to the top and to the bottom of the long side of the building, so it will recede to the same VP. Where does it stop?

9. To find the far edge of the slanted plane and intersect the ridge, extend the previously drawn slanted plane edge back to a 3-pt. VP directly over the eye level VP.

10. Now draw another slanted plane line from the top far corner of the building to the same 3-pt. VP. This line will intersect the ridge and form the far end of the roof.

Figure 4-6

11. Put eaves on the roof by extending the slanted lines down. Remember that all receding lines parallel to each other go to the same VP. The roof is complete.

Check your drawing to make sure that:

1. Two-point VPs are as far apart as possible and remain on the eye level.
2. The 3-pt. VP is directly above one of them.
3. All vertical lines are drawn vertically.
4. All receding lines parallel to each other go to the same VP.

Using the same procedure, draw the shed in figure 4–7. Place rafters on the wall by using the projection method in figure 3–7. Then project them forward from the 3 pt. VP used for the roof.

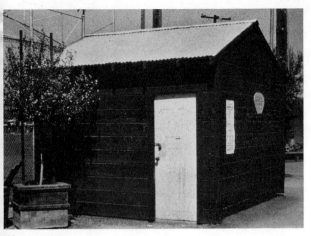

Figure 4-7

Roof on a One-Point Perspective Building Now try the same shed in one-point perspective, showing just the front wall with the roof slanting back. Remember that in one-point perspective the vanishing point is directly in front of where you are standing; so if you cannot see either side of the building, the vanishing point is somewhere within it on the eye level. The slanted plane vanishing point for the roof is directly over the eye level vanishing point. The corrugations on the roof all go to the same vanishing point. Now draw a similar shed very close to it, also in one-point perspective, using the same vanishing points. On this one you will see the front and one side, or part of it.

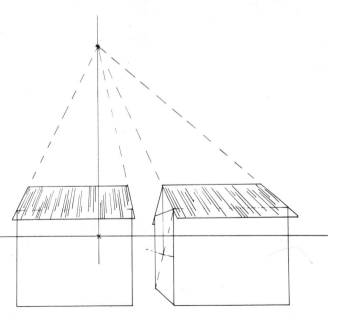

Figure 4-8

Check your drawing to make sure that:

1. The eye level VP is centrally located.
2. The 3-pt. (slanted plane) VP is directly above it.
3. All vertical lines are drawn vertically, and all horizontal lines are drawn horizontally.
4. All lines parallel to each other go to the same VP.

Using the same procedure, draw the shed in figure 4-9. Since these beams are not on a receding wall, they may easily be placed by direct measurement. Use the checklist from the previous drawing.

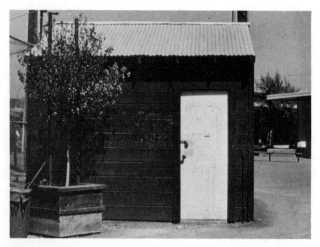

Figure 4-9

Box Flaps

Slanted plane vanishing points can be used to construct the open flaps of a box. Figure 4–10 is an example in two point:

1. Draw the box, in two point.
2. Now draw the angle of the largest flap. Extend it back into space to its 3-pt. VP. Draw its other edge in the same way.
3. The tuck-in flap goes in another direction. Is its slanted plane VP above or below eye level? Move along the receding slant from the corner closest to you and you will find it.
4. Now draw the other two flaps. The box is complete.

Figure 4-10

Now turn the box so that you see it in one-point perspective (fig. 4–11). Here the large flap of the lid is still slanted, but its slant is not receding from the picture plane, so it will not have a slanted plane vanishing point. The other two flaps, however, are slanting away from the picture plane, so each of these will have a slanted plane vanishing point. Draw the box in this position. Then use the checklist for the previous drawing.

Figure 4-11

The pages of an open book may be drawn in the same way.

The Slanted Plane as Ground

Roads Sometimes a slant is the ground plane. When a road or street goes uphill or downhill, the three-point vanishing point must be used to locate the slant properly.

Figure 4–12 shows a straight country road. Some parts of it are uphill and some downhill, with flat areas in between. Think of the road plane in segments divided by horizontals. Locate the uphill, downhill, or level vanishing point for each section and label each *up*, *down*, or *level*. You will find three vanishing points vertically aligned. See figure 4–13 for answers.

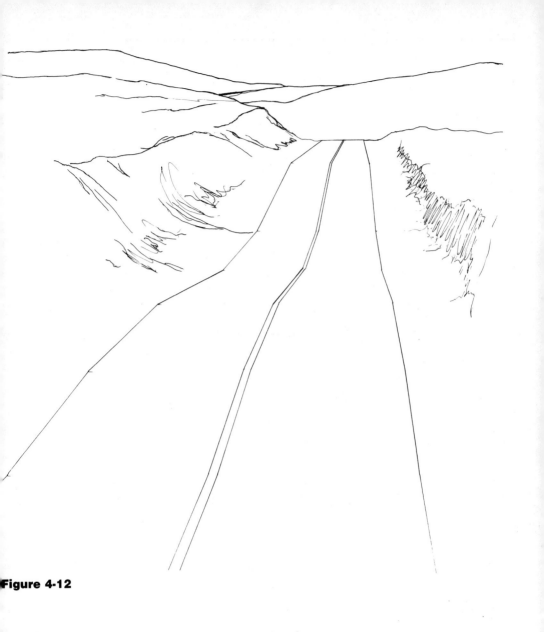

Figure 4-12

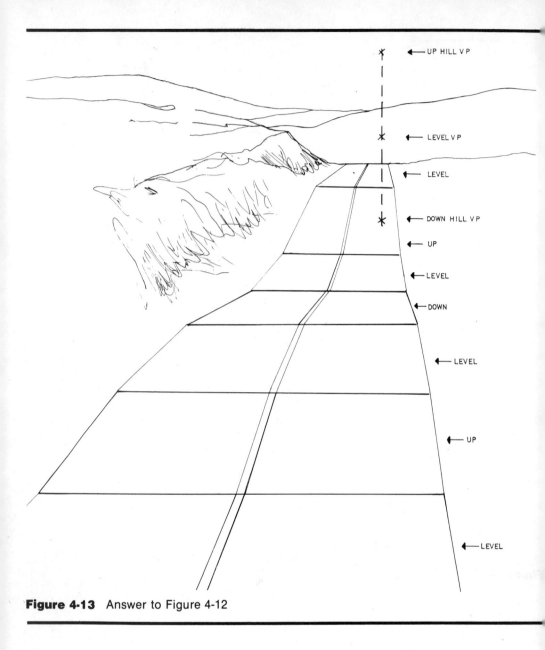

Figure 4-13 Answer to Figure 4-12

Now try drawing a slanted ground plane by drawing a city street on a hill, level only at cross streets (fig. 4–14).

1. Start with your eye level and vanishing point.
2. Now near the bottom of your paper, draw a level section receding to the eye level VP.
3. Draw a horizontal line across it where it stops. This will help you keep track of where you change slants.
4. Now take the street downhill to a downhill VP directly below the eye level VP, ending with another horizontal line.
5. A level section for a cross street next.
6. The next section goes uphill to an uphill VP directly above the eye level VP.
7. Then a level section.
8. Now uphill. Take it above eye level if you wish.

When a building is erected on a hill, its ground line follows the line of the hill, but the building is constructed with level floors, ceilings, windows, and doors. Consequently, except for the ground line, all receding edges of buildings will go to the eye level vanishing point. It is quite different with cars and trucks on a hill. They are not level, so their receding edges go to the same vanishing point as the street they are on.

Now add some buildings to your drawing.

You can further develop your drawing by:

1. Adding buildings on the right side of the street. To keep the buildings in proportion, measure horizontally from the buildings on the left.
2. Varying the heights of buildings, adding windows and doors.
3. Providing traffic lane lines, crosswalks, and pedestrians.
4. Adding cars or trucks. A passenger car is about four and a half feet high, five feet wide, and fifteen feet long. Vans, buses, and trucks are proportionately larger. Size judgments are made from dimensions already drawn. Remember that a car on a slanted plane recedes to that plane's vanishing point.
5. Shading the drawing, keeping the light direction consistent.

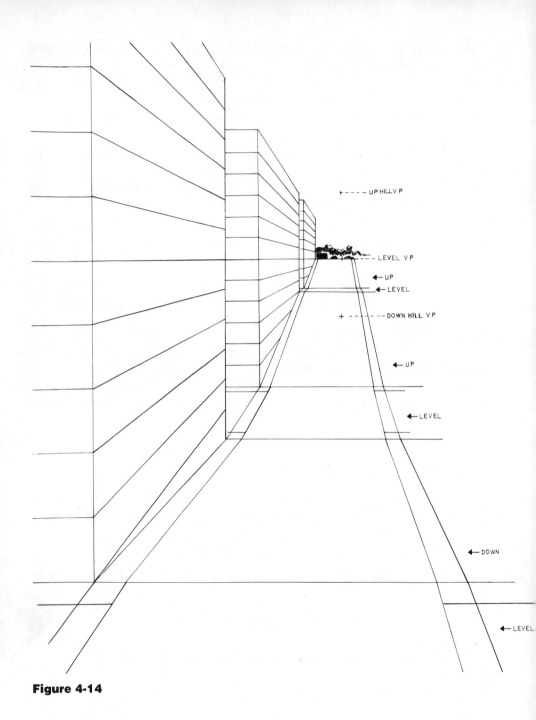

+ - - - - UP HILL V P

- - LEVEL V P

← UP

← LEVEL

+ - - + - - - DOWN HILL V P

← UP

← LEVEL

← DOWN

← LEVEL

Figure 4-14

Here receding lines on buildings represent floors (10 ft). The sidewalks are 5
wide and the street is 50 ft wide. These proportions are established by measurin
a nonreceding vertical and horizontal.

68

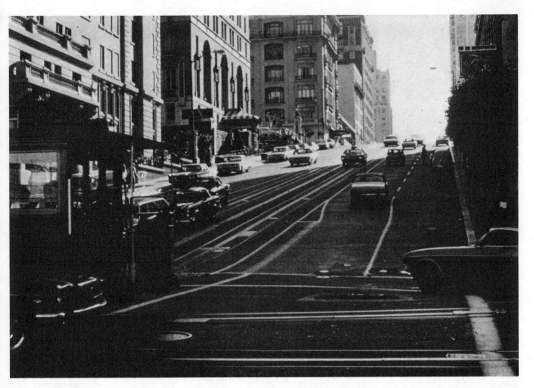

Figure 4-15

Figure 4–15 is a photo of a San Francisco street. Try to draw this one freehand, but use your straightedge if you need it.

1. Where are you standing?
2. Locate your eye level (level receding edges will help you).
3. This is in one point, so your eye level vanishing point is directly in front of you at the point where level receding edges meet.
4. How far below or above eye level are the cross streets?
5. To draw the general shape of the street you may find it easiest to start at the bottom of your paper and work back to the VPs.
6. Locate the VP for each slant as you come to it.
7. Include some of the buildings and cars.
8. If you wish, you can use your softest pencil to darken areas that are dark in the photo.
9. To help you get started, figure 4–16 locates the eye level VP and the slanted plane VP.

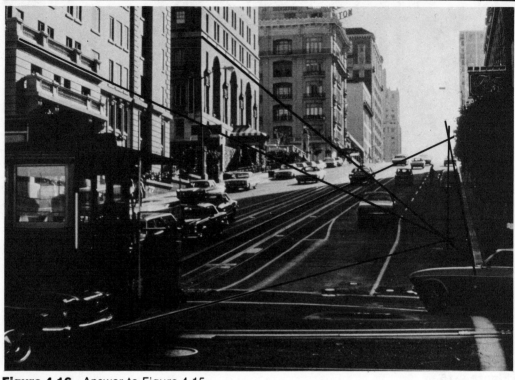

Figure 4-16 Answer to Figure 4-15

Wedge in Two Point Whenever it is convenient to draw the flat surface directly underneath a slanted plane, you may find the wedge helpful. It is an easy way to place the slanted plane exactly where you want it, and you don't need the three-point vanishing point to draw the edges of the slant correctly. The three-point vanishing point still exists, however, and may be used to check drawing accuracy if you wish. The wedge concept is often convenient for drawing ramps, awnings, stairs, pages of an open book, or wedges of cheese or cake. Draw a wedge in two-point perspective (see fig. 4–17):

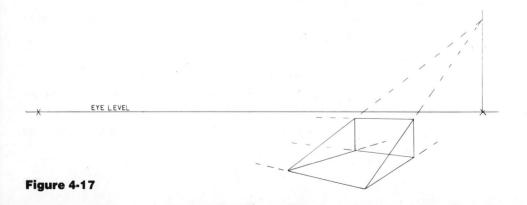

EYE LEVEL

Figure 4-17

1. First, draw the eye level and the VPs far apart.

2. Then draw a rectangle below eye level, like the bottom of a box, receding to the eye level VPs.

3. Make this wedge slant up as it recedes by drawing a vertical at the back corner on the right. The back corner on the left is farther away than the one on the right, so a vertical here is limited in height by a line from the top of the right vertical to the left VP. Now you have the back of a box.

4. The wedge is completed by drawing the edges of the slanted plane on each side from the top of the back to the bottom of the front.

5. You can check to see how accurate your drawing is by continuing the edges of the slanted plane. They will meet at a VP directly above the right-hand eye level VP.

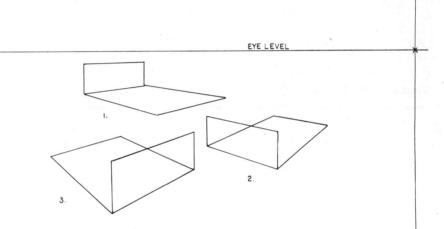

Figure 4-18

Complete the wedges in figure 4–18 and find the vanishing points. See figure 4–19 for answers.

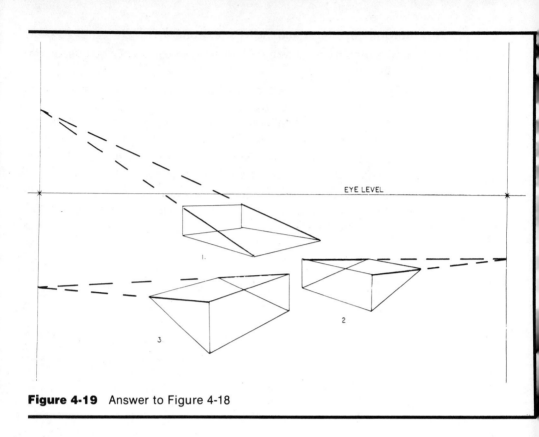

Figure 4-19 Answer to Figure 4-18

Now draw some wedges in other positions, in two-point perspective.

Wedge in One Point When the slanted plane vanishing point is used with one-point perspective as with the roofs of the sheds in one point, there is no two point, just one and three. Remember that the slanted plane vanishing point is used only when the slanted plane is receding from the picture plane. To draw a wedge in one point (fig. 4–20):

Figure 4-20

1. First, draw the eye level and a VP on it somewhere near the center.
2. Next draw a receding rectangle in one point. This is the bottom of the wedge.
3. Now draw the height verticals, both on the back or both on the front, and add a line connecting their tops.
4. Connect the top to the bottom on both sides, marking the edges of the receding plane.
5. Find the slanted plane VP by continuing the slanted edges back until they meet at a point either directly above the eye level VP or directly below it. If the height is at the back, it is an upward slant and the VP will be above. If the height is at the front, it is a downward slant and the VP will be below.
6. Draw one of each.

In figure 4–21 complete the drawings of wedges in one-point perspective and find the vanishing points. See figure 4–22 for answers.

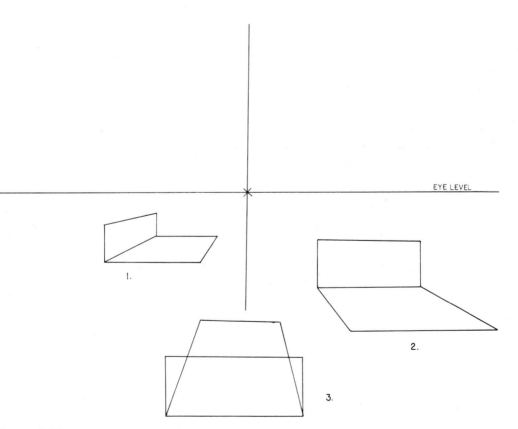

Figure 4-21

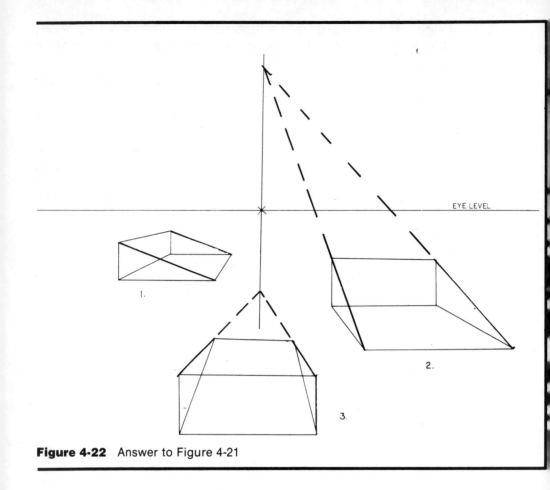

Figure 4-22 Answer to Figure 4-21

Stairs from Wedge, Slant Not Receding Many people have trouble drawing stairs, but it need not be a great problem. Most sets of stairs you will draw will occupy a highly visible and limited amount of space. When this is the case, the wedge can be used as a starting point. This has the advantage of allowing you to place the stairs exactly where you want them with no gap between the stairs and the wall or floor. To do this, place the bottom or flat surface of the wedge on the ground plane touching the wall. Think of the wedge as a ramp; a ramp with teeth in it (risers and treads) becomes a set of stairs. The riser is the vertical surface; the tread is the flat surface on which you step. When a wedge is seen in a profile view, the slanted plane is not receding; so the wedge does not have a slanted plane vanishing point. Each step can be drawn the same height by dividing the vertical height equally by measurement. Try it, using this list as a guide:

1. Draw the wedge with its slant not receding, in one-point perspective with the eye level above it.

2. Divide the height into four steps.

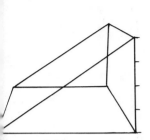

Figure 4-23

3. Now bring a horizontal line across from each division mark to the slant line and extend it beyond the slant line.

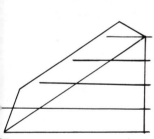

Figure 4-24

4. Each riser comes straight up from the slant line at the back of the previous tread to meet the tread above it. The near profile is complete.

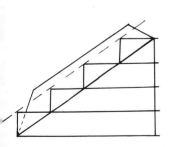

Figure 4-25

5. The bottom of each riser will recede toward the VP and stop at the fa[r] edge of the wedge.

6. The top of each riser will recede toward the VP and will stop at the poin[t] where it is intersected by a horizontal tread.

7. Vertical lines connect the top and bottom of each riser.

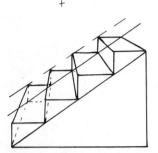

Figure 4-26

8. The stairs are complete. Check your accuracy by drawing a line throug[h] the top of each riser on both sides. These lines should be parallel to th[e] wedge slants and to a line through the bottom of the risers. All of thes[e] lines are drawn parallel to each other, since this slanted plane is n[o]t receding.

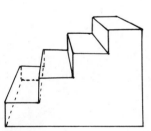

Figure 4-27

Now draw the stairs and house in figure 4–28.

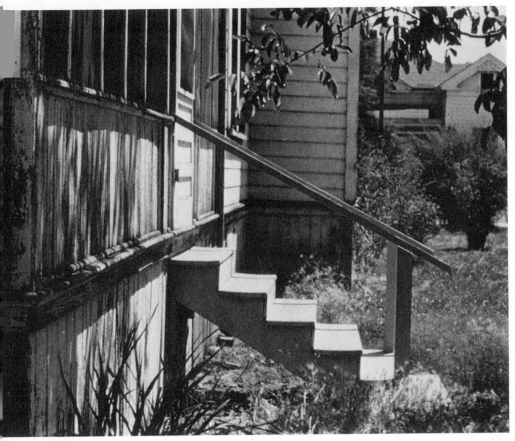

Figure 4-28

Stairs from Wedge, Slant Receding, One Point Suppose we see stairs in one
point with the slanted plane receding:

1. Start with a wedge in one point with the height at the back. Include eye
 level, VP, and slanted plane VP.
2. Divide the height equally by measurement into any number you wish.

+

+

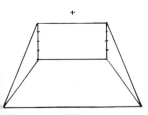

Figure 4-29

3. Now project these divisions forward to the slant line. Start at eye level VP and come forward through each division mark on both sides and through the slant. These are the treads.

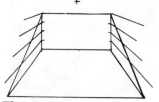

Figure 4-30

4. Vertically connect treads with a riser from the back of each tread on the slant line to the front of the next.

5. Check accuracy of your drawing with a line through the top of each riser. It should go to the same slanted plane VP as the line through the bottom of each riser.

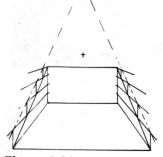

Figure 4-31

6. Connect the two profiles with a horizontal line through the bottom and the top of each riser. The stairs are complete.

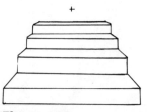

Figure 4-32

Now draw the stairs and house in figure 4–33. Show the ground line of the house wall on both sides of the stairs.

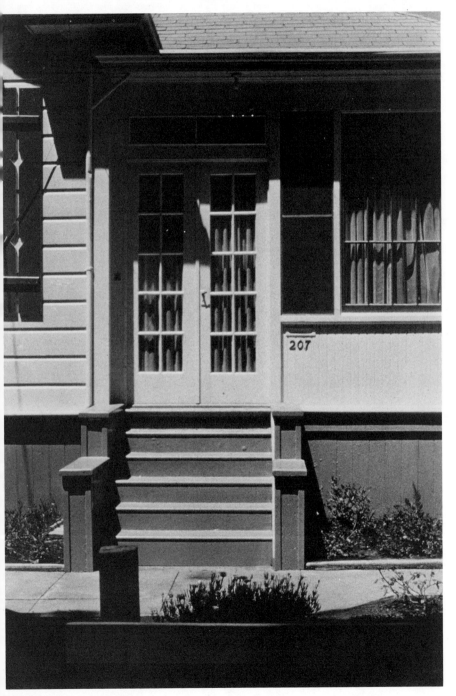

Figure 4-33

Stairs from Wedge, Receding, Two Point Try the same thing with stairs in two-point perspective:

1. First, draw a wedge in two-point perspective with its height at the back; include its hidden edges. Locate all three VPs and eye level.
2. Divide the height by measurement on the closest side.
3. Take these division points back to the eye level VP through to the other side, dividing it equally too.

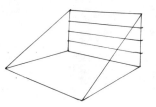

Figure 4-34

4. Project forward from eye level VP through divisions on both sides. Extend beyond the slants.

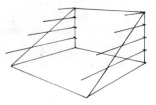

Figure 4-35

5. Connect with vertical risers as before.

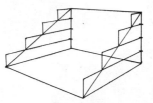

Figure 4-36

6. Connect edges of the treads across. They should go to the eye level VP.
7. Check your accuracy by drawing lines through tops and bottoms of the risers on each side. All four lines should go to the slanted plane VP.

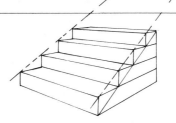

Figure 4-37

Now draw this:

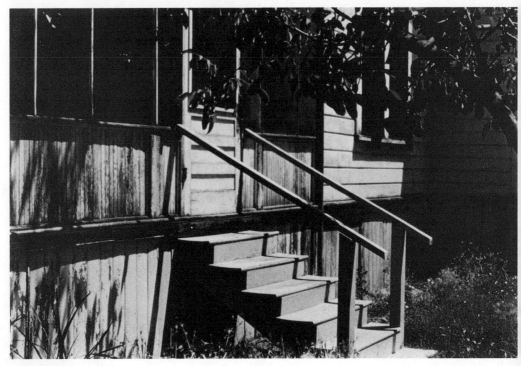

Figure 4-38

Stairs in Unlimited Space, Two Point Sometimes it is inconvenient or impossible to draw the flat plane of a wedge underneath stairs—for example, when you are drawing steps in a garden not connected to a building, or steps going up the side of a hill, or a long flight of stairs where you can't see the top or bottom. Another method can be used to draw these stairs in unlimited space. It is not at all difficult if you think of each step as a box. Try this method in two point:

1. First, draw the eye level and two vanishing points far apart.
2. Now, below the eye level, draw a long box the shape of a step. This first step establishes the proportions—height, length, and depth.

Figure 4-39

3. The first step has also established the slant or steepness for the stairs. To find the slanted plane VP draw a line at the end of the box from the bottom front to the top back and continue it to a point directly above the eye level VP on that side. Do the same on the opposite end; it will go to the same VP. All the risers will go up from this line on either side.

4. Draw a line from the top front corner of each end of the box to the same slanted plane VP. The tops of all risers will end on these lines.

Figure 4-40

5. The second riser continues straight up from the back of the first box on both sides, stopping at the slant plane line.

6. Connect the tops of these riser ends. This line if extended would go to the eye level VP.

7. The second tread (or top of the second box) goes back to its eye level VP, stopping at the slant plane line on each side.

8. Connect across. Two stairs are complete.

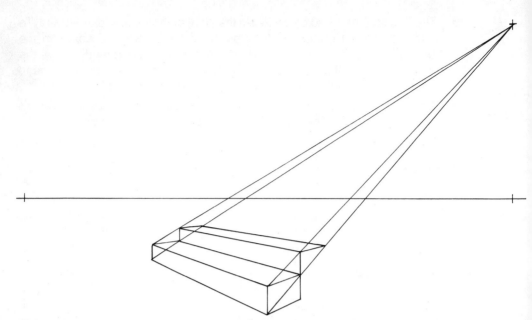

Figure 4-41

9. As you continue to build the stairs up as far as you like, you will find that above the eye level, part of each riser is hidden by the step in front of it. It will be helpful to draw those hidden lines to locate each step properly.

Figure 4-42

Now draw this (fig. 4–43):

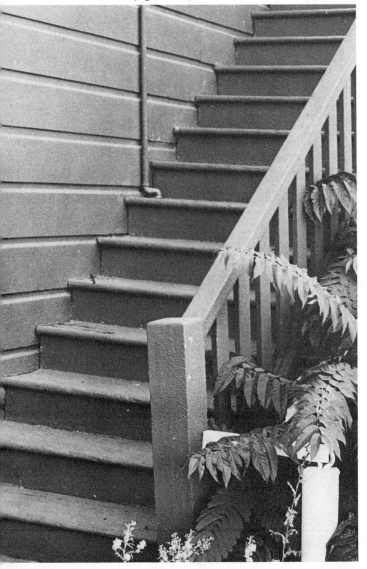

Figure 4-43

Stairs in Unlimited Space, One Point Now try this method for stairs in on
point with no side showing.

1. First, draw the eye level and centrally locate the vanishing point.
2. Next, draw a long box, which will be the first step, below the eye level.
3. Find the slanted plane VP.

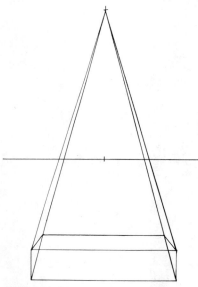

Figure 4-44

4. Draw the slant plane lines to the VP, marking the bottom and the top c
 the risers on each side.

Figure 4-45

5. Now draw the second riser straight up between the two lines on eacl
 side. Connect across.
6. Draw the tread between the slant plane lines to the level VP. Connec
 straight across to form the second step.

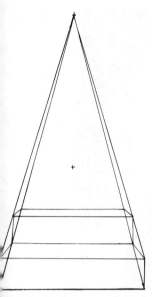

Figure 4-46

7. Continue as far as you like, taking the stairs above eye level. Hidden lines do not have to be drawn until you get above eye level.

8. For accuracy, check verticals, horizontals, and slant plane lines.

Figure 4-47

Now draw this (fig. 4–48):

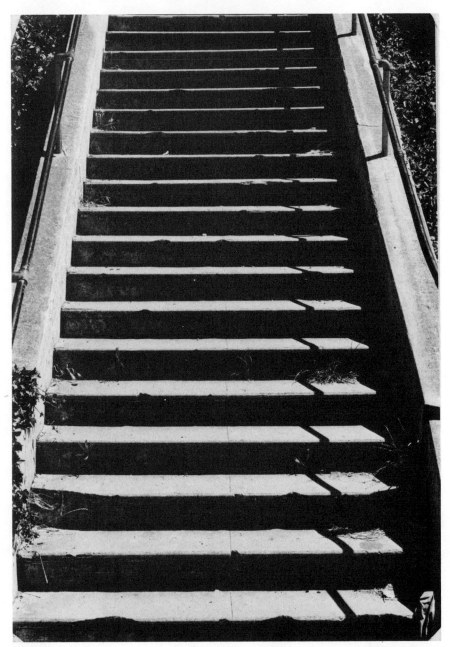

Figure 4-48

You have worked with several ways to use the slanted plane and its vanishing point. Now combine some of these in a single drawing by drawing a simple rectangular house with a shed roof, and a few steps ending with a landing or porch at the front door. Put a handrail on the steps and the landing. The handrail follows the slant of the steps. You may choose to do your drawing in one point or two point. If you have any problems, refer to the step-by-step instructions. Try for reasonable proportions.

When you have finished, check to be sure:

1. All lines parallel to each other and receding from the picture plane go to the same VP.
2. All flat receding planes go to a VP on the eye level.
3. All slanted receding planes go to a VP above the eye level.
4. All slanted plane VPs are directly above or directly below the eye level VP.
5. If one point is used, the VP is centrally located.
6. If two point is used, the VPs are far apart, preferably outside the drawing.

Here is a photo to draw from if you wish. Two more follow.

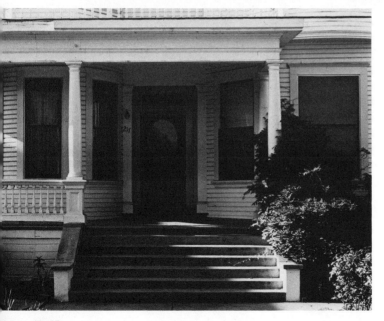

gure 4-49

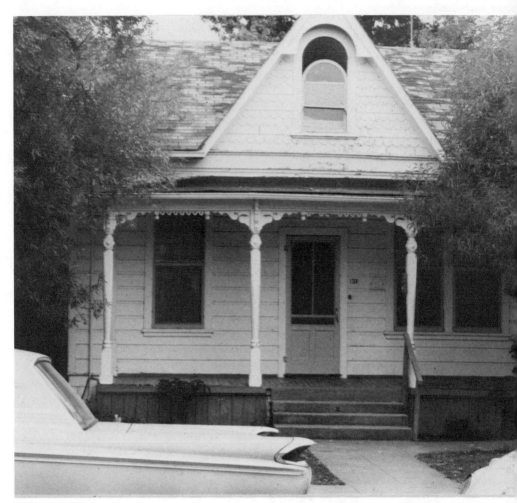

Figure 4-50

Figure 4-51

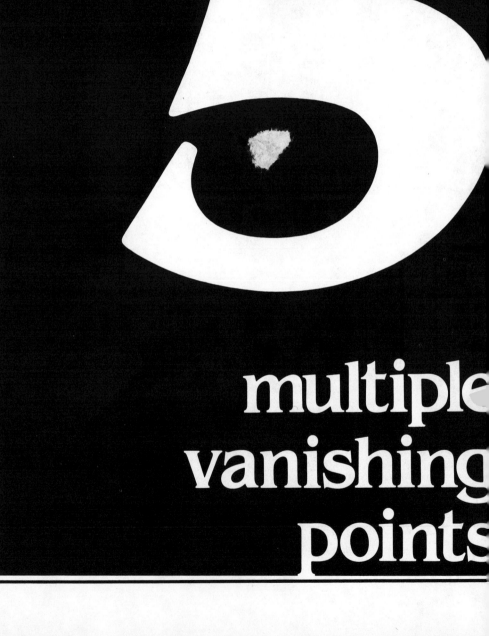

5

multiple
vanishing
points

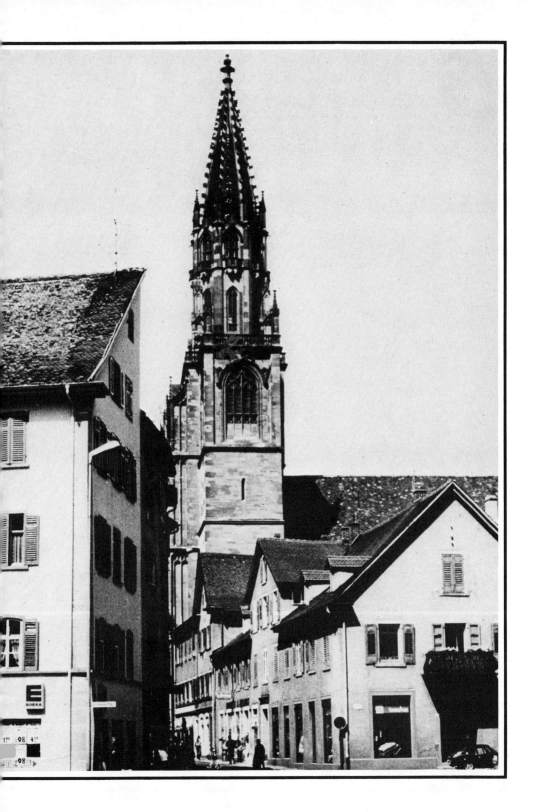

WHY IT HAPPENS

We know that all lines parallel to each other and receding go to the same vanishing point. We found this true of a single box and of a group of boxes placed parallel to each other, and of buildings erected parallel to each other. Sometimes, however, buildings, boxes, books, or pieces of paper on a table are *not parallel* to each other but are positioned at a variety of angles. In this case, each object will have its own vanishing point or set of vanishing points. If all objects are on a flat surface, their vanishing points will all be on the same eye level. In this way it is possible to have multiple sets of vanishing points in a single view.

Multiple vanishing points are used to show multiple directions in a single view.

Trace parallel receding edges on this photo. Find the vanishing points and the eye level. See figure 5–2 for answers.

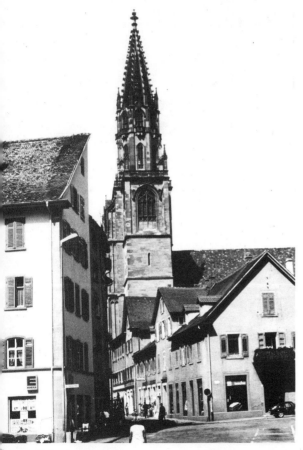

Figure 5-1

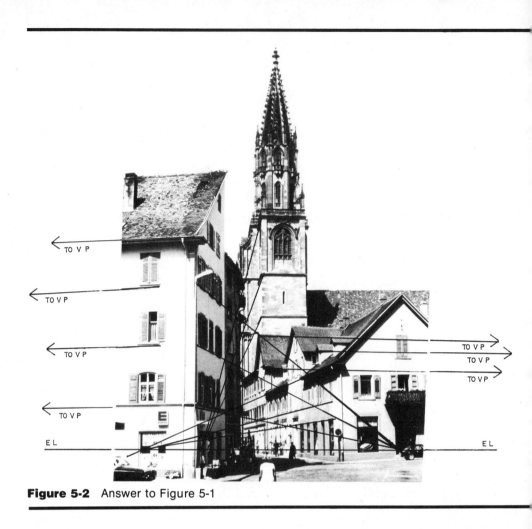

Figure 5-2 Answer to Figure 5-1

HORIZONTAL PLANES

Flat Road Changing Direction

Now let's use multiple vanishing points to draw a flat road that changes directio several times. When the direction changes, the vanishing point for each direc tional segment is repositioned along the eye level to the left or right. Line dividing the segments will be horizontal because the road is flat. A curving roa can be drawn as a series of straight segments with the angles smoothed out (se fig. 5–3).

Figure 5-3

1. Establish the eye level.
2. Locate a vanishing point (VP) anywhere you wish on the eye level.
3. Now, near the bottom of your paper draw a section of road going to the VP. A horizontal line will end this section.
4. Next find another VP on the eye level.
5. From the back limits of the first section, go toward the second VP and stop at another horizontal line.
6. Add a third VP and a third section, then a fourth, changing the direction of the road each time.
7. For a more finished result, the horizontals can be erased and the angles curved if you wish.

Road Changing Direction and Elevation

Now suppose a road is going uphill or downhill as well as changing direction to the left and to the right. Each section going up or down is a slanted plane and will have its vanishing point directly above or below the vanishing point it would have if it were flat. Figure 5–4 shows a road going up and down as well as to right and

left. Find the eye level and find the vanishing point for each section. Label each section *up*, *down*, or *flat*. When you are finished, check it with the answer, figure 5–6.

Figure 5-4

Now draw one of your own. Refer to figure 5–5 for procedure; yours will be different. When you are finished check to see whether:

1. All level sections go to an eye level VP.
2. All uphill sections go to a VP above eye level.
3. All downhill sections go to a VP below eye level.
4. All sections end with a horizontal line.

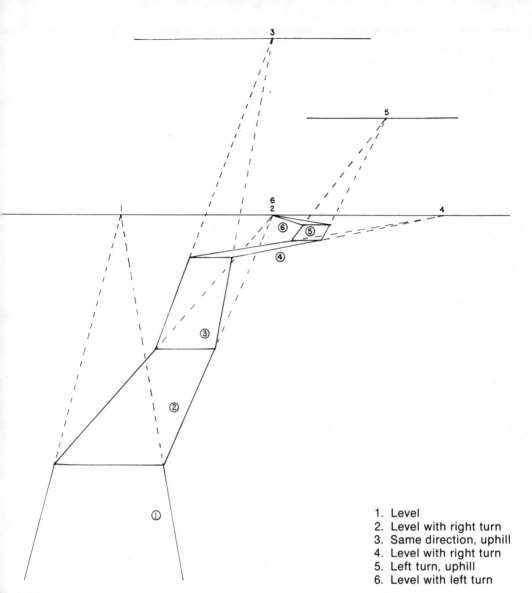

Figure 5-5

1. Level
2. Level with right turn
3. Same direction, uphill
4. Level with right turn
5. Left turn, uphill
6. Level with left turn

If you would like some extra practice using these principles, try drawing a receding road intersecting another road at a sharp angle; or draw two city streets intersecting at right angles, in one point or two point.

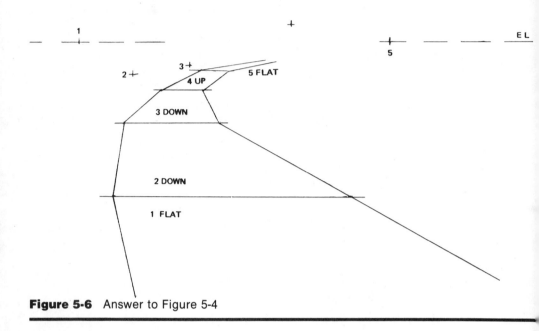

Figure 5-6 Answer to Figure 5-4

VERTICAL PLANES

Folding Screen

These principles can also be applied to vertical planes. Draw a folding screen standing at random angles. This is the procedure for figure 5–7:

First, establish the eye level with a vanishing point on it.

Panel 1 Draw a vertical line crossing the eye level, and receding lines from its top and bottom toward the VP. Stop at the next vertical, which forms the far edge of the first panel. All panels parallel to the first one will recede to this VP.

Panel 2 Now add a second VP on the eye level. If the second panel is to come forward, extend it forward from the second VP through the back of the first panel. Make it as wide as you wish.

Panel 3 This panel is not receding, so it has no VP. The top and the bottom are parallel to the eye level.

Panel 4 This panel recedes to another VP.

Panel 5 This one comes forward parallel to the second panel.

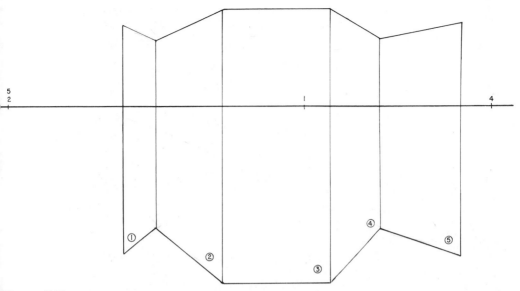

Figure 5-7

Now try drawing a screen of your own. Make this a seven-panel screen with panels of random widths standing at random angles. Show one panel not receding, and the next panel standing at right angles to it.

Make sure that:

1. All VPs are on the same eye level.
2. The 1-pt. VP is centrally located.
3. All panels connect.

THREE-DIMENSIONAL FORMS

So far you have been using multiple vanishing points only for surfaces, but the same principles apply as well to three-dimensional forms.

Stack of Books

Here is a stack of books in one-point perspective. There is one vanishing point for the entire stack.

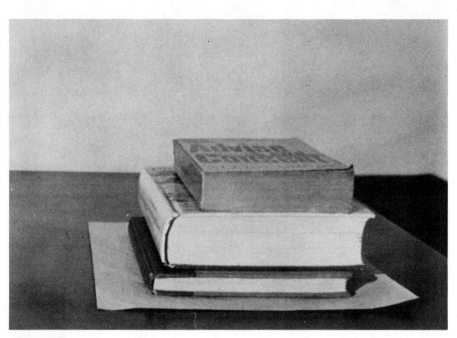

Figure 5-8

Here the books are stacked at different angles, each with its own set of two-point vanishing points. Since they all are flat, all vanishing points are on the eye level

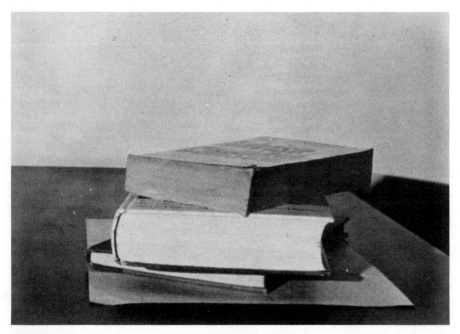

Figure 5-9

If you trace the several sets of vanishing points for this stack of books, you will find that each set is far apart, but not always the same distance apart. A *pivot point* is a convenient way to locate several sets of vanishing points such as these. Try it.

1. First establish the eye level.
2. Then draw the bottom book in one point with its VP.
3. Now select a point directly under the VP and well below the area where you want to draw the books. This will be the pivot point.

+ PIVOT

Figure 5-10

4. Place the square corner of a piece of paper on this point. At the points where its edges cross the eye level, establish a set of VPs for the second book.
5. Now rotate the paper around the pivot of its corner to locate a set of VPs for the third book.
6. Do the same for a fourth book. Notice that the paper's edge moves along the eye level slowly as it approaches the center, and faster as it moves away from the center.

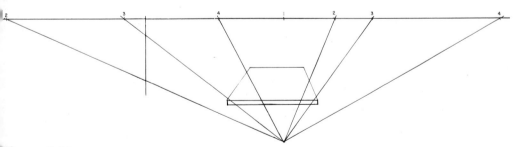

Figure 5-11

7. Draw the books from the bottom to the top. Number the VPs and the books correspondingly (fig. 5–12).

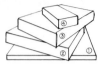

Figure 5-12

Spiral Stairway

If you want more practice with this idea, you might think of all these books being the same size and thickness, and placed at the same angle of rotation. You would then have a spiral stairway.

1. Draw the first step in one point. Find the slanted plane vanishing point.
2. Draw a horizontal line through this VP. All three-point VPs will be on this line.
3. Establish a pivot point directly below the 1-pt. VP.
4. If you want a 30-degree turn for each step, as in this drawing, place your right angle on the pivot 30 degrees above the horizontal line. Establish VPs for the second step.
5. The third step will have another 30-degree turn, so turn your right angle on the pivot point 60 degrees above the horizontal for the third step. Establish VPs for the third step.
6. The fourth step will have another 30-degree turn, or 90 degrees from the horizontal. Therefore this step is in one point, just like the first step in profile. All eye level VPs are now established.
7. Draw the riser for the second step, starting with the inside edge. It is

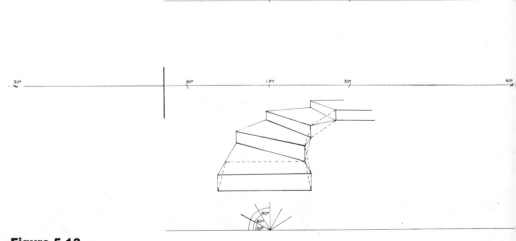

Figure 5-13

drawn straight up at the back of the first tread, stopping at the slant plane line from the top of the first riser.

8. The bottom and top of the second riser recede to the 30-degree VP on the eye level. The riser ends where it crosses an extension of the first tread.

9. Both sides of the second tread go to the 30-degree VP on the right.

10. Locate the slanted plane VP for the 30-degree step directly above the eye level 30-degree VP on the right. Draw slant plane lines to it from the top and bottom of the riser.

11. Draw the vertical for the third riser between these slant plane lines.

12. The bottom and top of this riser recede to the 60-degree VP on the eye level, stopping where the riser crosses an extension of the second step.

13. Both sides of the tread for the third step recede to the right-hand 60-degree VP on the eye level.

14. Locate the 60-degree slanted plane VP as before and draw the slant plane line to it from the top and bottom of the third riser.

15. Draw a vertical line for the fourth riser between them.

16. The bottom and top of this riser recede to the 1-pt. VP used for the first step, since this step is also in one point. This riser stops where it crosses an extension of the third step tread.

17. Tread edges of the fourth step are not receding; draw them horizontal.

Using multiple vanishing points, draw from the photo in figure 5–14.

Figure 5-14

6

the circle in perspective

ELLIPSE

Any circle seen in perspective is called an ellipse. It will appear to be elongated instead of perfectly round, but its ends are never pointed. In figure 6–1, label each circle with a C and label each ellipse with an E. Answers are in figure 6–2.

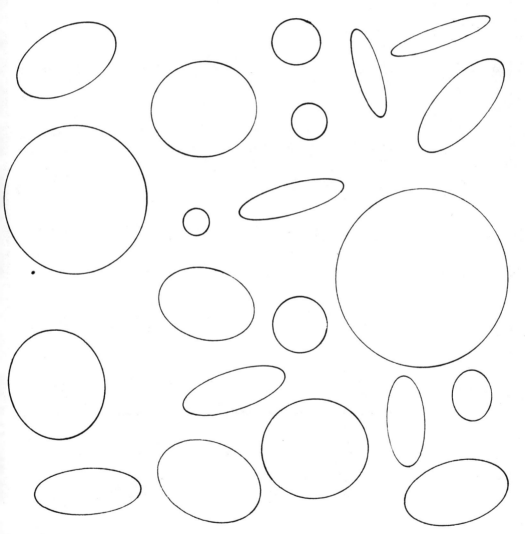

Figure 6-1

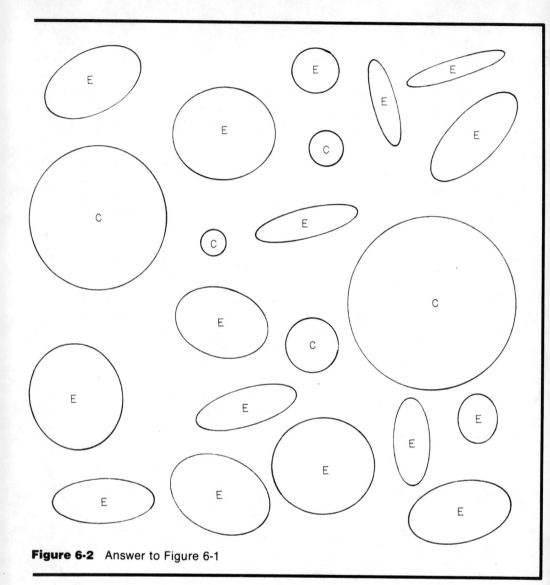

Figure 6-2 Answer to Figure 6-1

Let's take a look at some ellipses. Here is a coffee mug with a round top and bottom and straight sides. Looking directly into the mug you can see that its top rim and its bottom rim are circles.

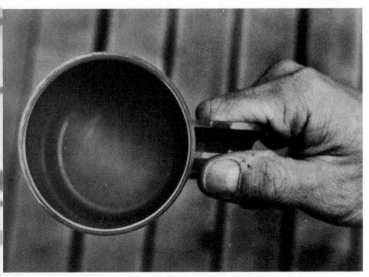

Figure 6-3

Put it on the table. The top is now seen as an ellipse. The bottom is also an ellipse, but you see only the front half of it.

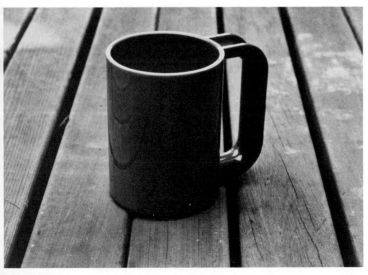

Figure 6-4

As you lift the mug slowly, the ellipse top appears narrower and narrower until it appears as a straight line on your eye level. If you continue to raise it above eye level it appears rounder again.

At eye level an ellipse appears as a straight line; the farther it is above or below the eye level, the rounder it appears.

Now turn the mug on its side with its sides parallel to the picture plane and place it far to the right. The top is seen as an ellipse. Now slowly move the mug horizontally across the table and you will see that the ellipse narrows increasingly until it appears as a straight vertical line directly in front of you, where it would cross a one-point vanishing point. Continuing past this point it appears increasingly round again.

An ellipse seen vertically directly in front of you (crossing the one-point vanishing point) appears as a straight line; the farther it is to the left or right, the rounder the ellipse appears.

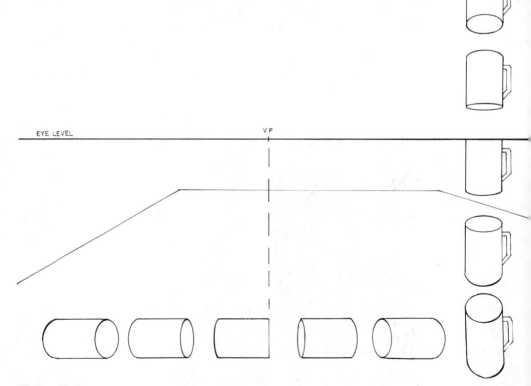

Figure 6-5

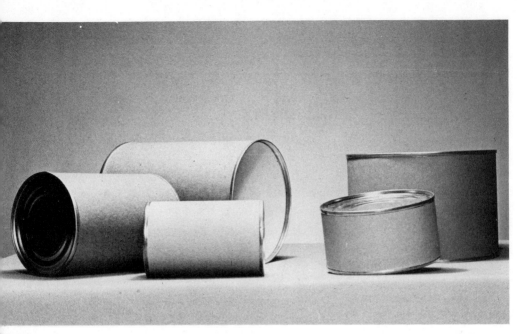

Figure 6-6

Find the eye level and one-point vanishing point in figure 6–6. Answers are in figure 6–7.

Long and Short Axes

An ellipse has a long axis and a short axis. These are center measurements, and they are always at right angles. The long axis is the longest possible measurement across the ellipse, and the short axis is the shortest possible measurement across the ellipse.

Go back to figure 6–1 and draw the long and short axes on each ellipse. Check to be sure that:

1. The long and short axes of each ellipse divide each other exactly in half.
2. The long and short axes of each ellipse are at right angles to each other.

(Answers are in figure 6–8.)

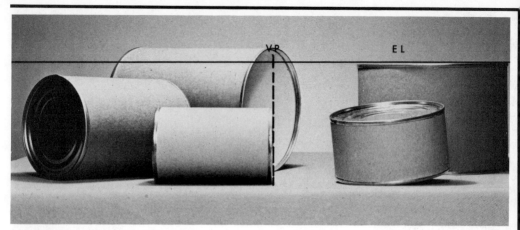

Figure 6-7 Answer to Figure 6-6

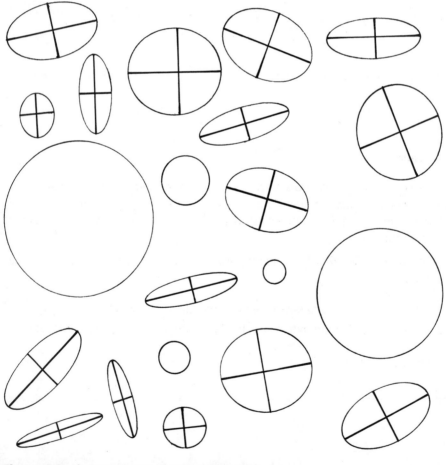

Figure 6-8 Answer to questions on page 113

To draw an ellipse start with the long and short axes. The ellipse may then be drawn freehand or with an ellipse template or with this method:

1. Place pins at the ends of the long axis and tie a loop of thread snugly around them.
2. Mark thread at the short axis cross point (center) and remove the loops from the pins.
3. Place the marked center at the outside end of the short axis.
4. With the string taut, find the points where the loop ends touch the long axis, and reposition the pins at these points with the loop around them.

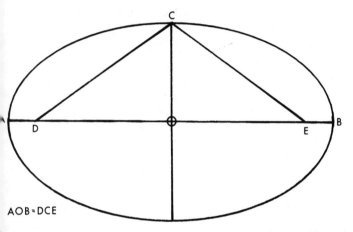

AOB=DCE

Figure 6-9

5. Hold your pencil vertically inside both strands of loop and draw a half ellipse, keeping the string taut. Then lift your pencil and complete the ellipse.

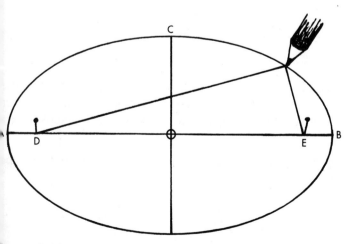

Figure 6-10

Since the ellipse is a circle seen in perspective, the center of the circle is not the center of the ellipse, because the far half appears smaller than the near half. Let's see why that happens. Suppose you have a square rug seen in one-point perspective. Draw it. In the example below, the rug has a circle pattern divided into sections from a center point. Find the center with cross diagonals. Draw a horizontal line through the center and a receding line through the center toward the vanishing point. The square is now divided into eight equal parts. The center of the back, of the front, and of each side has been located. To draw the round pattern, swing an ellipse through all of these center points. Now find the center of the short axis of the ellipse by measuring. The center of the short axis is in front of the rug center. This is the location of the long axis of the ellipse. The front half of the rug appears longer, and it also appears wider.

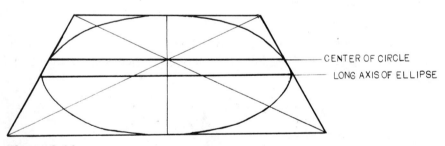

Figure 6-11

The center of the circle seen in perspective is not in the center of the ellipse; it is in back of the long axis on the short axis. It is useful to remember this fact when you are drawing any circular pattern such as a clock face or the spokes of a wheel.

Draw from one of the following two photographs. Remember that the center of the pattern is in back of the center of the ellipse.

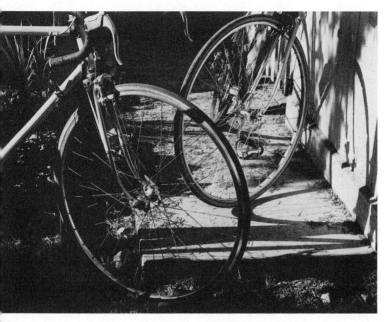

Figure 6-12

Figure 6-13

The ellipse in nature is often somewhat irregular, but the same principles apply. Draw from one of the following two photographs.

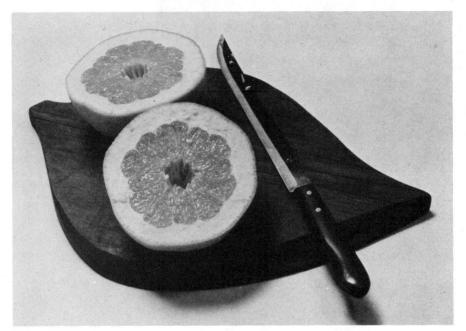

Figure 6-14

Figure 6-15

CYLINDER

When the ellipse is the end of a cylinder, the short axis lies on the center core of the cylinder, no matter what its position. Here are some cylinders with ellipses for ends. Draw the short and long axes of the ellipses and the center core of the cylinders. (Answers are in figure 6–17.)

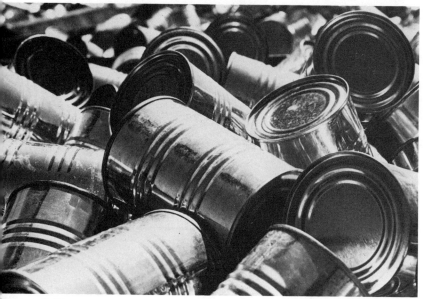

Figure 6-16

The cylinders in figure 6–18 are in many angled positions not parallel to the picture plane as in figure 6–6, so you should not compare one cylinder with another to find the eye level or vanishing point. Instead, compare the two ends of *one* cylinder. The rounder end will be farther from eye level or vanishing point. Only when the center core of the cylinder is parallel to the picture plane (not receding) will its elliptical end appear as a straight line when crossing eye level or vanishing point. For this reason, *when drawing the cylinder in any position, start by drawing the center core, then the axes of both ellipses.*

Now draw from figure 6–7. Establish the size and position of each cylinder by first drawing its center core, then the axes of both ellipses.

When you have finished, check to see that.

1. Each ellipse long axis is at a right angle to its short axis and to the center core of the cylinder.
2. The cylinder end farthest from the eye level or vanishing point is rounder than the end closer to eye level or vanishing point.

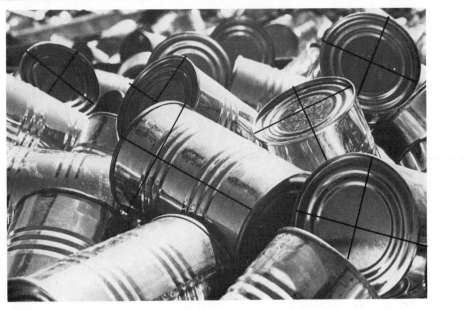

Figure 6-17 Answer to Figure 6-16

Figures 6–18 and 6–19 are photos of the cylinder used in architecture. Choose one of the photos and draw it. Use the same procedure and checklist as in the last drawing.

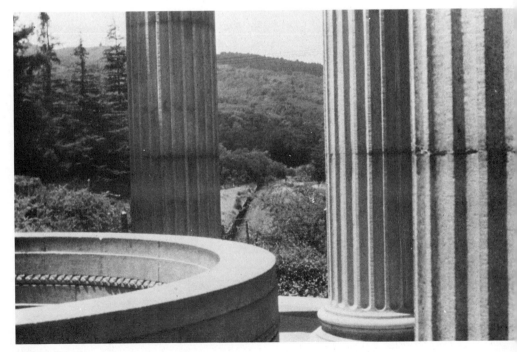

Figure 6-18

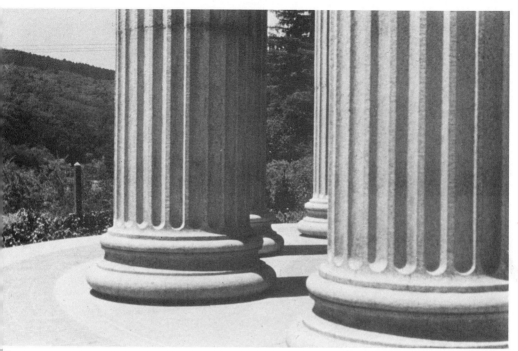

Figure 6-19

Cylinder Changing Direction

When a cylinder changes its direction, the new direction can be shown by the overlapping profile of the section closest to you.

Pipes, cylindrical air ducts, and limbs of trees often make turns in direction. When these turns are seen in profile (not receding) the outline explains the change in direction. To explain whether a new direction recedes or advances, draw the overlapping profile of the section closest to you. This method is very helpful in drawing natural cylindrical forms, which, though irregular, follow the same basic rules. Shading is another help in showing the form by using lines that go around the cylinder and follow the curve of its elliptical cross section.

The drawings of a tree in figure 6–20 show outline only, overlapping, and directional shading. Chapter 9 deals more completely with shading and cast shadows.

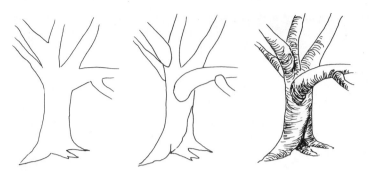

Figure 6-20

Figure 6-21

Figures 6–21 and 6–22 are photos of cylinders in nature. Choose one and draw it.

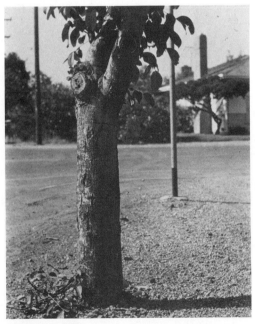

Figure 6-22

The cone is a tapered cylinder. Its point is on the center core line. In this drawing of cones and partial cones, find the ellipses and draw the long and short axes of each. Draw the center core line of each conical form and locate the cone point for each. (Answers are in figure 6–24.)

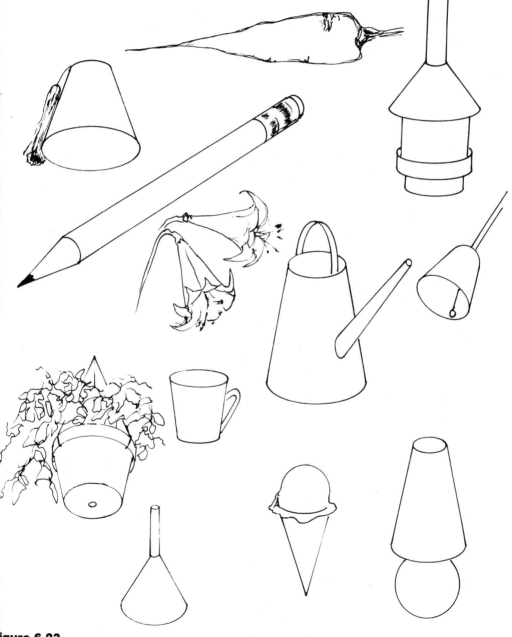

Figure 6-23
CONES

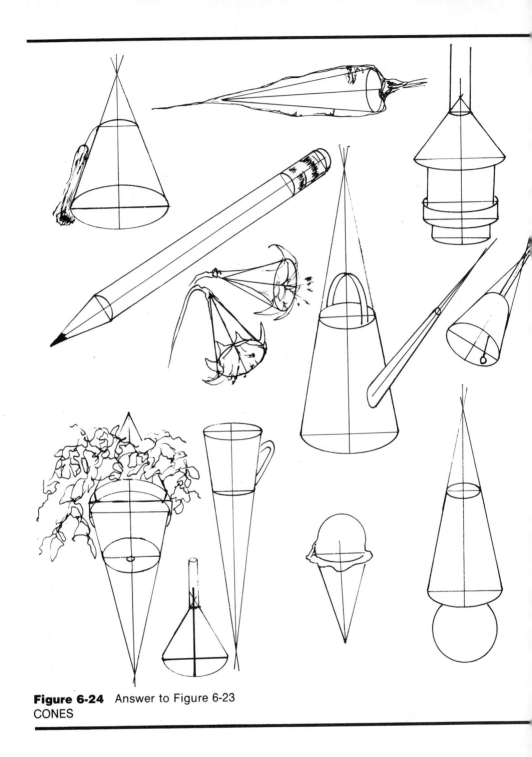

Figure 6-24 Answer to Figure 6-23
CONES

Here is a photo of some conical shapes. Draw from the photo. To check your accuracy, use the checklist for cylinders and make sure the cone point is on the center core line of the cylinder.

Figure 6-25

DOME

A dome is a half sphere, though many dome-like shapes are shallower or deeper than half spheres. *To draw a dome, find the ellipse of the base and the center point of the rounded top, located on an extension of the short axis of the ellipse.*

To locate the top of a dome:

1. Draw the dome as a half circle.
2. Draw the ellipse on the same axis.
3. Add a tangent to the ellipse parallel to its long axis through the top of the

short axis and through the dome edge. (A tangent is a straight line touching a curved line at one point only.)

4. Draw a line from this intersection to the center.

5. Draw another line from the center at a right angle to line 4 through the dome.

6. From this intersection point, draw a line parallel to the ellipse long axis extending through the dome height.

7. The point where this line crosses the dome height is the top of the dome.

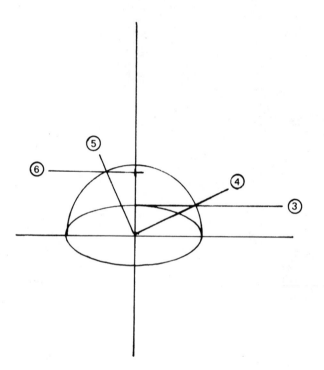

Figure 6-26

Here are some drawings of domes and dome-like shapes. For each dome draw the ellipse and its long and short axes. Put a small X at the top point of each dome. (The answers are in figure 6–28.)

Figure 6-27
DOMES

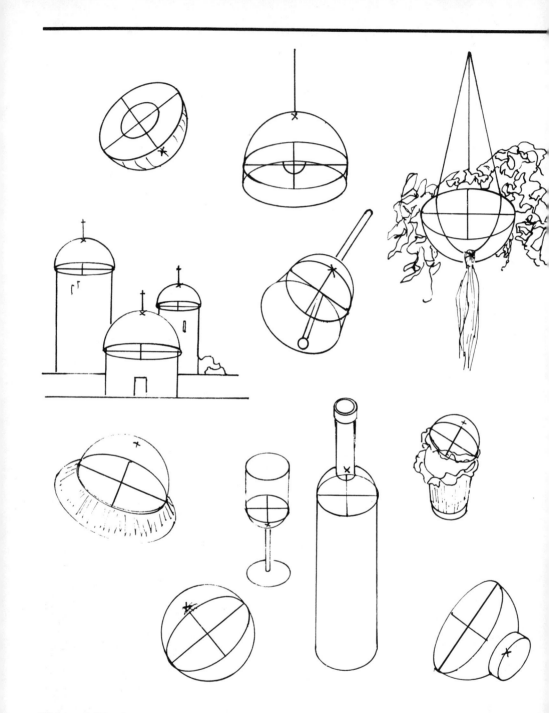

Figure 6-28 Answer to Figure 6-27
DOMES

Now draw from this photo, figure 6–29.

1. Locate the camera's eye (eye level).
2. Position the dome by drawing its ellipse and axis.
3. Extend the short axis to the height of the dome (center point).
4. Connect the curving edges from the ellipse to the center point.

To check the accuracy of your drawing, use the ellipse checklist. Also make sure that the center point of the dome is on an extension of the short axis of the ellipse.

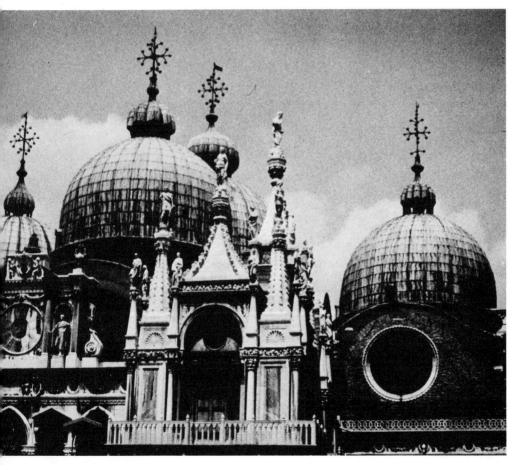

Figure 6-29

Dividing a Dome

A dome can be divided into equal segments by projection from a nonreceding circle.

Try this by drawing an umbrella (fig. 6–30).

1. Draw the ellipse, which is the open edge of the umbrella. The continuation of the short axis will be the handle.
2. Continue the short axis on the other side to make the dome as flat or as deep as you wish.
3. Extend the handle line (center core) downward and draw lines parallel to it from each end of the long ellipse.
4. Draw a nonreceding circle within these lines.
5. Divide the circle into as many parts as you wish (here, eight). These become the ribs of the umbrella seen as a plan view.
6. Take these division points back to the ellipse, then over the dome to the center.

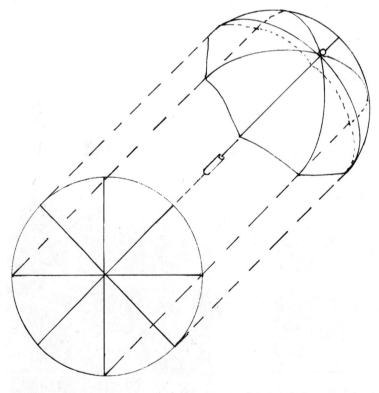

Figure 6-30

Using this method to project from a circle to an ellipse you can locate evenly spaced divisions on ellipses such as clock faces, spokes in a wheel, flutings on a column, or edgings on a plate. It can also be used for irregular spacings sometimes found on round rugs, lettering on round signs, or emblems.

Figure 6–31 shows some familiar domes. Draw them.

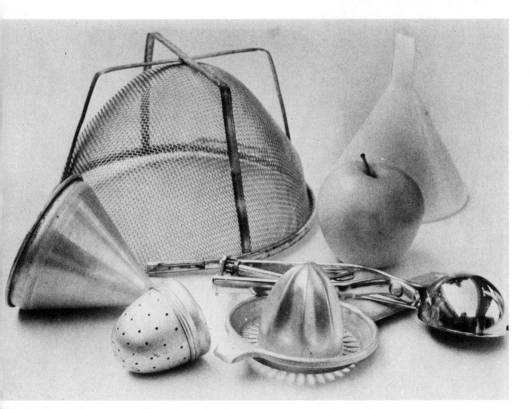

Figure 6-31

7

proportioning

7

A properly proportioned drawing is one in which all objects are in proper size relationship to each other, no matter where they are placed in space. For instance, in drawing the interior of a room you would want the furniture to be a reasonable size in relation to the height of walls and doors, so that adults in the room could use it comfortably. Similarly, people in a room should not appear to be giants or dolls.

Most general proportioning is done by eye, or estimate, but some drawings require exact proportions, so you will need to practice both. Exact proportioning and scale drawing are discussed in chapter 8.

ESTIMATING SIZE

When two objects on a level surface are located the same distance from the picture plane, their bases will be on the same horizontal line. Their comparative heights can then be measured by a parallel horizontal. Width may also be measured.

However, when two objects on a level surface are located at *different distances from the picture plane,* a line through the base of both will cross the eye level at a vanishing point. If a line from the top of one object to this vanishing point also goes through the top of the second, they are the same height. Width may be judged by comparing height to width of one object with the height to width of the second.

REPOSITIONING

Any object may be repositioned horizontally across a drawing without changing its distance from the picture plane or its size.

In figure 7–1, draw the chair moved out to the center of the room without changing its distance from the picture plane. It will occupy square 1. When you have finished, check to be sure that the height is the same in both positions and that they are the same distance from the bottom of the drawing. Now draw the chair moved to square 2 by projecting it from square 1 back to the vanishing point.

Figure 7-1

136

Any object may be repositioned forward or back in space by projecting it forward from a vanishing point or back to a vanishing point. It will retain its size relationship (proportion) to other objects in the drawing even though it is a different distance from the picture plane and therefore measures a different size.

Combining these two repositioning devices, any object can be moved—forward, backward, or across—to any desired position in space without changing its size in proportion to the rest of the drawing. Try this by drawing a room interior in one-point perspective. Include at least one door, one window, and one piece of furniture or counter touching a wall, and one piece of furniture not touching a wall. This can be any kind of room you want, but keep furniture and accessories appropriate to the room's purpose and in believable proportion.

1. First, draw the back wall in one point showing the floor and ceiling.

2. To place your eye level on the back wall, decide whether you are seated or standing. If you are sitting, your eye level is about halfway up the wall; if standing, about two-thirds of the way up. Draw it.

3. Since this is one-point perspective, the vanishing point should be centrally located somewhere on the eye level.

4. From the vanishing point, extend forward through the top and bottom corners of the wall to show a side wall.

5. A standard door height is 6 ft. 8 in., which is a little more than three-fourths of the wall height. Approximate that height and draw the top of the door on the back wall. The door will be two feet to three feet wide, and since the width is not receding, it can be taken from the height measurement to complete the door.

6. Window height is usually the same as door height. Put the window on the side wall. To do this, extend the door height horizontally across to the corner. Through this point, a line projected forward from the vanishing point will provide a line on the side wall for the height of all doors and windows. Windowsill height varies, but is often three feet to four feet from the floor. Approximate this at the back corner and project it forward on the side wall. Make the window any width you wish.

7. Furniture size is estimated on the back wall at the corner. Draw the area a piece of furniture would cover on the wall and the floor. These surfaces can then be projected forward, backward, or across with lines from the vanishing point through each corner. Keep lines light until you have found the desired position.

8. If you wish to draw a piece of furniture not parallel to the walls, it will be in two point. Be sure the vanishing points are far apart and on the same eye level as the rest of the room.

Use figure 7–2 as an example for reference. In your own room, include as much or as little detail as you wish.

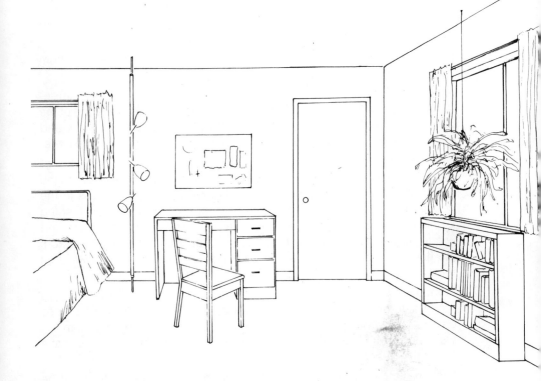

Figure 7-2

138

Now draw a room interior in two-point perspective.

1. First, draw a vertical for the back corner of the room.
2. This time you are seated, so your eye level will be a little less than halfway up the wall. Draw it.
3. Draw the vanishing points far apart—outside the drawing. Extend forward from each of these through the top and bottom of your vertical, creating two walls, some floor, and some ceiling.
4. The height of everything in the room will be measured proportionately from this back corner room height. Furniture width will be projected from one wall, and furniture depth from the opposite wall. Choose any kind of room you wish and furnish it appropriately and proportionately. Include at least one door and one window, several pieces of furniture with at least one piece of furniture not touching a wall, and at least one piece of furniture not parallel to a wall. Here is a checklist to help you judge the accuracy of your drawing. When you are sure the drawing is correct, erase the construction lines. Add shading if you wish.

Checklist

1. Is your eye level halfway up the wall or slightly below?
2. Are all vanishing points on the eye level?
3. Are the vanishing points far apart, outside the drawing?
4. Are the windows and doors the same height at the top?
5. If each piece of furniture were pushed back to touch a wall, would its height and width in relation to the wall be reasonably comfortable for adult use?

PEOPLE IN PERSPECTIVE

This shortcut may help you to draw a group of adults at various distances in space. If you and the adults are standing on a level surface, their heads will be approximately on your eye level. You can thus draw people in proportion to each other when there is no architecture or other reference for their height. People can be drawn very small (far away) or quite large (close to you), but if their heads are on or very near your eye level, they will appear to be standing on the same level surface. If you are seated and a group of adults is standing, their waistlines will be on your eye level.

If you are inexperienced in drawing the figure, use a simple symbol—an elongated triangle helps here. For the male torso, the width is at the shoulders; for the female torso, invert it.

Draw an interior or exterior view showing a group of people at various distances. Indicate whether you are sitting or standing. When you have finished, check to be sure that the people are well proportioned to each other and to the architecture.

Draw from an actual scene or from one of the following photos (figs. 7-3 and 7-4).

Figure 7-3
YOU ARE STANDING

Figure 7-4
YOU ARE SEATED

8

exact
proportioning
and
scale drawing

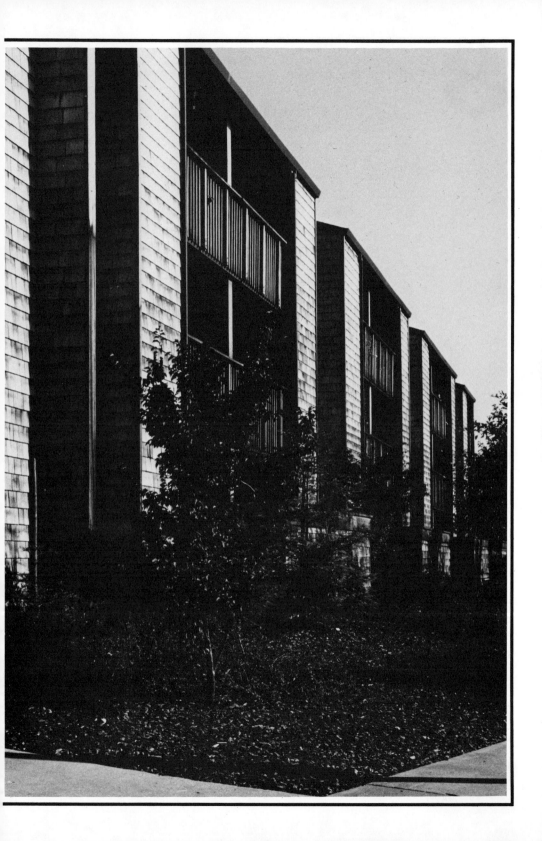

8

CALCULATING RECEDING DIMENSIONS

In estimating proportions many judgments are made "by eye." These are estimates of the depth of a receding dimension used in judging the width of a door on a receding wall, the depth of the first square of a sidewalk, or the proportions of the riser to the tread on a stair step. Some drawing purposes, however, require exactly correct proportions, and some further require a stated relationship to full-size measurements. This is called *scale drawing* or "drawing to scale." In these drawings a notation is provided showing how many inches or fractions of an inch equal one foot. Scale drawing is essential in architectural planning and interior designing. Plan views and nonreceding elevations are done by measurement, but they are difficult to visualize in terms of the three-dimensional space being described, whereas a perspective drawing in scale will immediately and clearly show the intent of the design.

General Principles

Here are some principles that should help:

1. Nonreceding dimensions can be measured.
2. Receding dimensions can be measured when they are seen in profile (90-degree rotation), or side view.
3. The perspective effect diminishes with distance; therefore *it is important to establish the distance from which you are viewing.*

Angle of Vision

An experiment in chapter 1 demonstrated diminishing size with increased distance by holding the hand at three distances from the eye. In figure 8–1, a diagram using a cube shows more precisely what was happening. This profile shows an eye looking at the same size cube from several distances. As the distance from the eye increases, the angle of vision decreases.

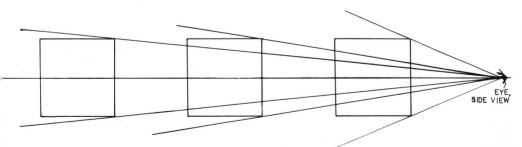

EYE, SIDE VIEW

Figure 8-1

The station point (SP) is where you are stationed or standing. It is directly in front of the one-point vanishing point. To measure the distance between your eye and the object viewed, you need to see this distance in profile (from the side) or as a plan view (looking down from the top). These views are nonreceding and therefore measurable.

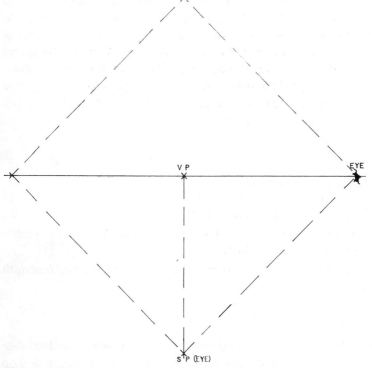

Figure 8-2

Figure 8–2 shows the distance between your eye and the subject in two views at once, front and side; the front view is a plan view, the side view is a profile. They measure the same because the front station point is located on a vertical line directly below the vanishing point at a 45-degree angle with a line to the profile or side view of the eye. This shows a way to measure the receding distance between the viewer and the object viewed. When locating the station point in the profile or measurable view, remember that:

1. It is on the eye level.
2. A line connecting it to the front SP forms a 45-degree angle with the eye level.

Distortion

If you construct an equal distance on the other side of the vanishing point below eye level, you will have a half square with a right angle at the front station point. This represents the normal 90-degree angle of human vision. Distortion occurs beyond this area. Reverse this triangle above the eye level and you can draw anywhere within the square without distortion.

THE CUBE IN ONE-POINT PERSPECTIVE

The cube is a convenient shape to work with since all of its sides measure the same. Any nonreceding edge of the cube can be measured to give you the measurement of any receding edge. Multiples of the cube in any direction can give accurate measurements of receding irregular shapes.

Drawing the Cube

Here is a simple and accurate method for drawing any cube in one-point perspective:

1. Draw the eye level and vanishing point (VP).
2. Establish the station point (SP) on the eye level to the right or left of the VP.
3. Draw the front (nonreceding) face of the cube and its receding edges to the VP.
4. Draw lines from the station point to the corners of the cube (fig. 8–3).

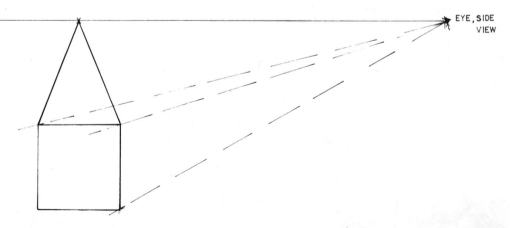

EYE, SIDE VIEW

Figure 8-3

5. At the point of intersection with the receding top, establish the depth with a horizontal to complete the cube (fig. 8–4).

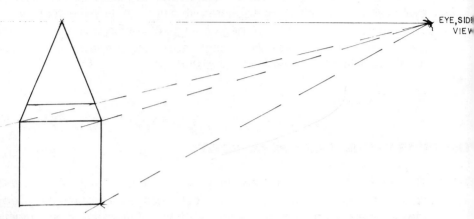

EYE, SIDE VIEW

Figure 8-4

6. If the shape is not to be distorted (within the 90-degree angle of vision) AB should be no smaller than BC.

Figure 8–5 shows some cubes in one-point perspective.

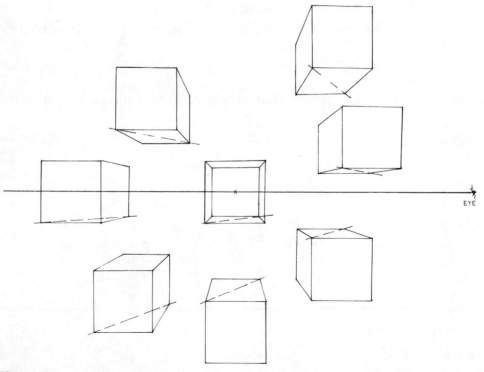

EYE

Figure 8-5

Now draw some one-point cubes of your own in exact proportions. Each face of each cube is a square, but only the top or bottom needs to be calculated.

Drawing a Square

A chessboard (fig. 8–6), since it is square, can be thought of as the top face of a cube. Find the eye level, vanishing point, and station point. (Answers are in figure 8–7.)

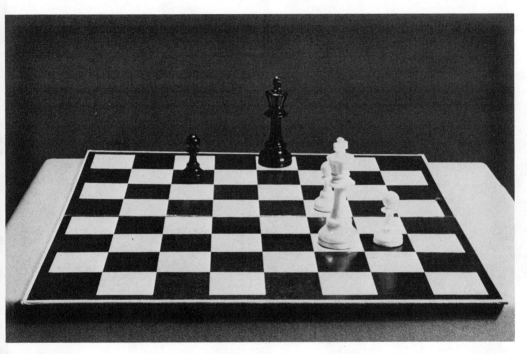

Figure 8-6

Now draw a chessboard (eight squares by eight squares). Think of it as the top face of a cube; it will not be necessary to draw the whole cube, only the top.

1. Start by drawing the front edge, eye level, vanishing point (VP), and station point (SP).
2. Draw a line from the SP to the front corner on the opposite side. Its intersection with the receding depth establishes the back edge of the board.
3. The front horizontal is divided by measurement. These divisions go to the VP.
4. Where the diagonal crosses the receding lines, draw the horizontal divisions.

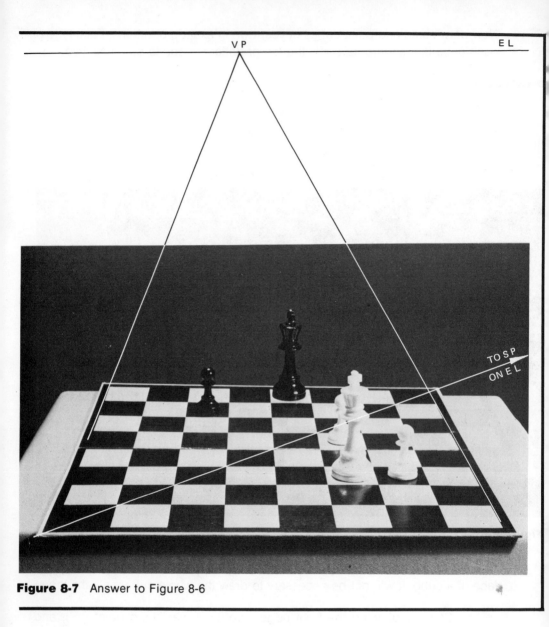

VP E L

TO S P
ON E L

Figure 8-7 Answer to Figure 8-6

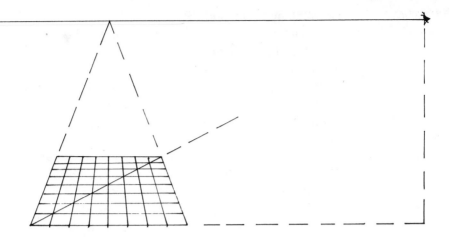

Figure 8-8

Scale Drawing

Now try projecting forward from the vanishing point for a drawing of a tiled kitchen counter in one-point perspective (fig. 8–9). This will be a scale drawing using these measurements:

> The eye level is 5 ft from the floor.
> The counter is 3 ft high and 2 ft deep.
> The tiles are 4 in. square.
> You are standing 8 ft from the back wall.
> The scale at the back wall is: ¾ in. = 1 ft

Figure 8–9 is half the size your drawing will be. Directions are on the next page.

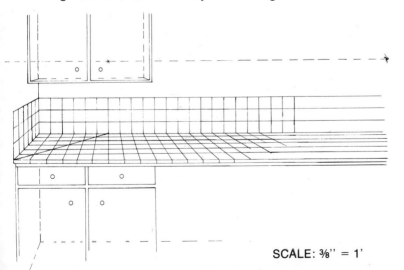

SCALE: ⅜'' = 1'

Figure 8-9

1. Draw the eye level and VP.

2. Locate the bottom of the wall as follows: ¾ in. = 1 ft, so 5 ft = ¾ in./ft × 5, or 3¾ in. Therefore, draw the bottom of the wall 3¾ in. below eye level.

3. The back of the counter top should be located in the same way: 3 ft × ¾ in./ft = 2¼ in. Therefore, draw the back of the counter top 2¼ in. above the floor.

4. Locate the SP as follows: 8 ft × ¾ in./ft = 6 in. to the right of the VP on the eye level.

5. Measure the divisions for the tiles (4 in. = ¼ in.) along the back wall of the counter top, with one division directly below the VP. Project lines from the VP through these divisions forward.

6. Draw the angle of the vision line from the SP through the division point directly below the VP and extend it beyond, crossing six receding lines (2 ft). At the 2 ft intersection a horizontal forms the front of the counter.

7. Draw horizontals where receding lines intersect the diagonal, and extend them to the end of the counter.

8. Continue three rows of tile up the back wall and up the side wall at the corner.

9. Add drawers below and cupboards above.

THE CUBE IN TWO-POINT PERSPECTIVE

Drawing the Cube

Drawing the cube in two-point perspective is a different problem because you need to establish depth for two receding dimensions that are not always equally visible. This can be demonstrated by rotating a cube on a table. Your position (station point) remains the same in front of the cube, but as the cube rotates, its vanishing points slide back and forth along your eye level with each change in position. You had some practice with repositioning sets of vanishing points when you drew the stack of books in chapter 5. In that drawing you *estimated* the depth of each book, but now you will see how to exactly *calculate* a receding depth in two-point perspective. Use the same approach as you did with the cube in one point; *superimpose a plan view on a side view to get the front view.* Here is a simplified, accurate method. As you draw it refer to figure 8–10.

These fence posts are evenly spaced because they are evenly spaced on the plan view, but as you can see, this method will work just as well with unevenly spaced divisions.

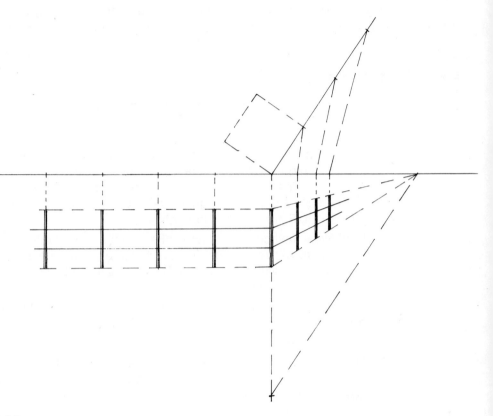

Figure 8-12

1. Draw the horizon line (HL), here the picture plane line (PP); draw the plan view on the PP.

2. The VP is at the right on the HL; the SP is on a vertical below the fence corner. Locate either by choice, then find the other by drawing a line connecting them which is parallel to the plan view receding direction.

3. Above the SP draw the top and ground lines of the fence, horizontal to the corner, then receding to the VP.

4. Equal sections between posts are determined by measurement on the plan view. Draw a line from each division toward the SP stopping at the PP, then continuing straight down to the ground line of the fence.

5. Complete the drawing with wires or crosspieces as you wish.

Combined Cubes

Any rectilinear form can be drawn as a combination of cubes, and any irregular form can be accurately drawn by encasing it in a cube or combination of cubes. This is why artists speak of "blocking in" a rough drawing—they are estimating the space for any given object by drawing the block (cube or cubes) that encases it.

Scale Drawing of Stairs

Try a combination of cubes in the form of some stairs in two-point perspective in scale as in figure 8–13.

1. First, establish the proportions and scale. Most steps have risers no more than 6 in. high and treads at least 9 in. deep. The stairway should be at least 3 ft wide. Using these dimensions a block of four stairs would measure 3 ft wide, by 2 ft high, by 3 ft deep. A convenient scale might be 1 in. = 1 ft. Figure 8–13 is half this size.

2. Now place the horizon line (HL), VPs, and the closest edge of the block. Since there will be 4 risers, 6 in. each, the block will be 2 ft high and in our scale that will measure 2 in. Divide this line into four half-inch segments, one for each tread.

3. If this edge goes above the HL, draw the PP at a convenient distance above it.

4. Locate the SP.

5. Draw the plan view touching the PP. Draw it 3 in. (3 ft) on the left for the stairway width, and 3 in. (3 ft) on the right for the depth, because each tread is 9 in. deep, or ¾ in. on scale: ¾ in. × 4 = 3 in. Measure the treads along this side.

6. Now draw receding lines to the VPs from the top and bottom of the perspective view of the height and from each riser division measured on it.

7. Draw a line from each corner and division on the close side of the plan that goes toward the SP, stops at the PP, then continues vertically down to intersect the receding lines. The profile is complete.

8. Connect across to complete the far profile. Tread divisions may be projected down on the far side to help you check the accuracy of your drawing.

9. Be sure to note the scale you have used.

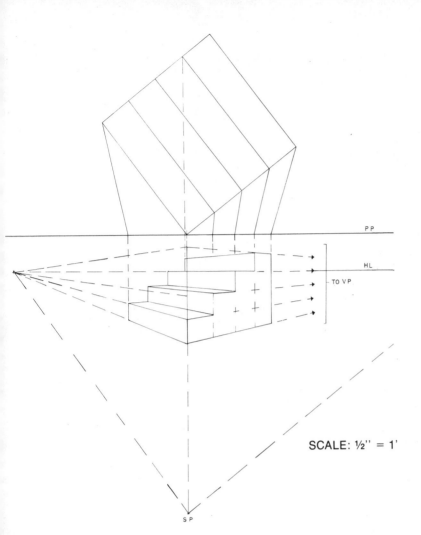

PP

HL

TO VP

TO VP

SCALE: ½" = 1'

SP

Figure 8-13

Scale Drawing of Room Interior

By this time, you should be able to draw a room interior in exact proportions and correct scale. One-point perspective is a little easier and faster than two point because there is only one receding dimension, but two point is almost as easy and fast. Since interiors are usually shown in two point, draw an interior in two point (see fig. 8–14).

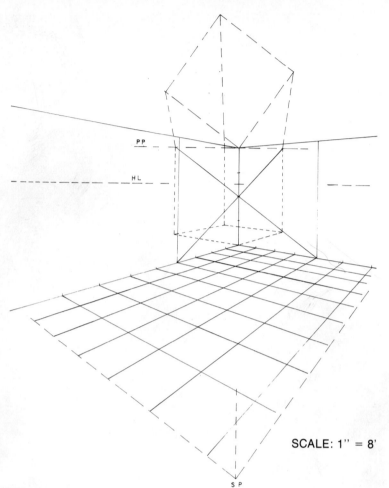

PP

H L

SCALE: 1" = 8'

Figure 8-14

1. First, decide the scale (here, 1 in. = 8 ft).
2. Draw the back corner of the room. Standard ceiling height is 8 ft (here, 1 in.); add a comfortable eye level (here, standing).
3. Draw the vanishing points (VPs) as far apart as possible and place them outside the drawing. (Your finished drawing may be smaller than your paper size.)
4. Now extend lines forward from the VPs through the top and bottom of the corner to form the ceiling and floor lines of the walls on both sides.
5. Establish the SP and the PP conveniently above the HL. Remember that there will be a right angle at the SP formed by lines to the VPs.

6. In relation to the plan view, remember that when establishing proportions you should use the largest measurement possible to save time and increase accuracy. In this case, it would be the 8 ft back corner of the room. We will draw an 8 ft cube extended in back of the room to find an 8 ft width projection on each wall. The plan view will be an 8 ft square (here, 1 in. square).

7. Projected down, an 8 ft cube is in back of and touching the corner of the room.

8. The center of the wall height is found by measuring at the corner and projecting along the walls forward from the VPs.

9. The cube sides are projected forward by diagonals on each side, establishing an 8 ft width on each wall. Remember, when proportioning with diagonals, take special care to make the first lines accurate, as any error will be multiplied. These 8 ft wall sections can be divided into 4 ft or 2 ft widths and can be extended to any length your space requires. These measurements can also be projected across the floor or ceiling from VPs forward. For instance, you might find it convenient to divide the floor into 2 ft squares to help you position furniture more quickly. Keep construction lines light, as you will want to erase them for your finished drawing.

From here on the drawing is up to you. Figures 8–15 and 8–16 may be used for ideas if you wish. The amount of time it takes will depend on the amount of detail you want to include. Remember that details are less noticeable across the room and are often merely suggested, but whatever you include should be in correct scale.

Here are a few standard measurements for reference:

doors:	6 ft 8 in. high, width 2 ft to 3 ft (2½ ft average)
windows:	the same top height as the doors; sill height and width, no limit of variation.
table heights:	coffee tables, often 15 in.
	game tables, 26 in.
	dining tables, 30 in.
chairs:	seat height, 16 in. to 18 in.
kitchen counters:	36 in. high, 24 in. deep
stairs:	no more than 6 in. risers; no less than 9 in. treads
bed height:	2 ft
chest of drawers:	many variations, often 3 ft to 4 ft high

Please include at least one window, one door, and at least one piece of furniture not touching a wall. Make it as attractive as possible, with the furniture arranged

conveniently and comfortably, and appropriately selected for the intended purpose of the room. Following the next checklist you will find two photos to draw from if you wish. Before erasing construction lines and adding shading (if desired) use the checklist to be sure your walls and furniture are correctly proportioned and positioned.

1. Are all horizontal lines exactly horizontal, and are the verticals exactly vertical?
2. Do all receding edges go to the proper vanishing point?
3. Is the eye level consistent with a sitting or standing view?
4. Is any piece of furniture occupying the same floor space as any other?
5. Is all furniture within the walls of the room?
6. If projected back to a wall, would each piece of furniture be the correct height and width?

If you have answered yes to all of these except number 4, you have drawn a room in correct proportion and scale.

Figure 8-15

Figure 8-16

9

shading and cast shadows

9

Shading and cast shadows are very useful in drawing and painting; they can create a pattern of dark shapes to strengthen a composition, set a mood, or suggest a time of day or season of the year (fig. 9–1).

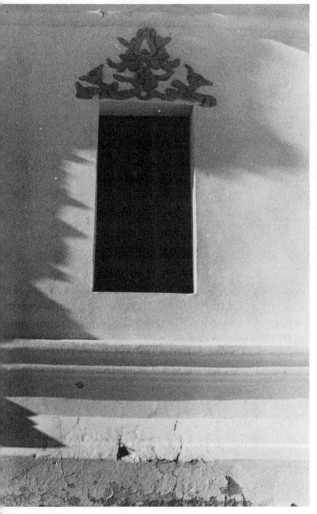

Figure 9-1

They can also clarify three-dimensional expression by describing the forms that cast shadows, and by describing the direction and texture of the surface on which the shadow falls (fig. 9–2).

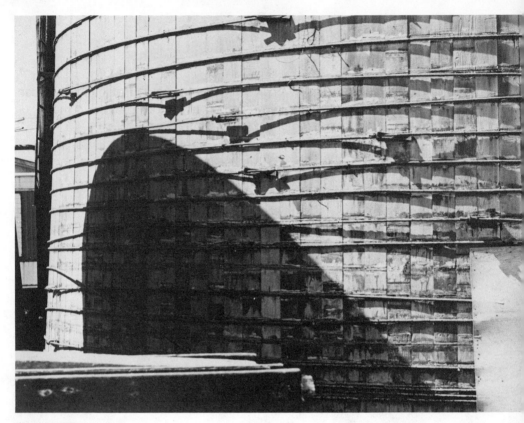

Figure 9-2

SOME GENERAL CONSIDERATIONS

Clarity of Shadow Edges

Some shadows are vague and diffused almost to the point of being nonexistent. This is observed on an overcast or foggy day, or when light is coming through a frosted window or from an electric light designed to minimize shadows. Such shadows are sharp only where the form contacts the surface. On a bright clear day, when shadows are most clearly defined, the decreasing clarity along a shadow edge is directly related to the distance between the form casting the shadow and the surface on which the shadow is cast. The closer these are, the clearer the shadow edge; as the distance increases the shadow becomes fuzzier (fig. 9–3).

Figure 9-3

Darkness of Shadow

Generally a bright light produces a dark shadow, but other factors sometimes
modify it. Multiple light sources produce multiple shadows that can partially
cancel or reinforce each other, with the brighter, closer light producing the
dominant shadow. This can give the effect of a shadow edge within a shadow,
which makes part of the shadow lighter (fig. 9-4).

Figure 9-4

An illuminated shadow has a single dark edge, but its interior is lighter. This happens when light from an illuminated surface bounces back into a shadow area, carrying with it the color of the reflecting surface (fig. 9–5).

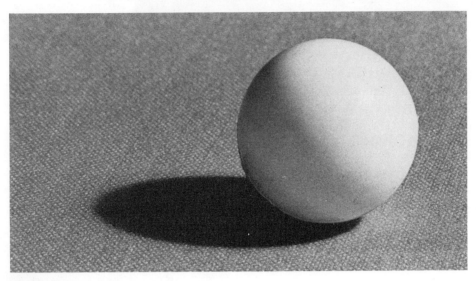

Figure 9-5

You will become more aware of these phenomena as you observe them further and drawing them is the best way to learn to see them.

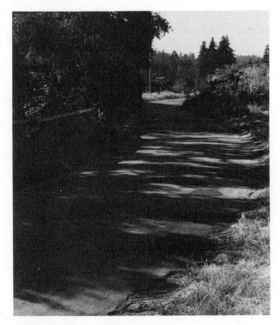

Figure 9-6

Many shadows are so complicated that it is inconvenient to find them by any mechanical means; they are drawn "by eye." However it is well to remember that outdoor shadows are changing constantly; during the time it takes to complete your drawing the shadow pattern may change considerably. Therefore many artists make a small sketch of shadow patterns before they start in order to keep shadows consistent in the finished work. If you add new forms or rearrange existing forms, remember to make their shadows agree with the rest of the composition. For this purpose it is important to know how to find the correct shadow shapes; methods for finding them follow, but first here are some definitions and determining factors.

Definitions

Shading refers to the darkening of a form on the side not illuminated by the light source.

Cast Shadow refers to the darkening of a surface where another form or plane is interrupting the light source.

Illuminated Profile refers to the edge of the illumination on a form; it is where its shading starts. The shadow is cast from this edge.

In figure 9–7 identify the shading, cast shadow, and the illuminated profile. Answers are in figure 9–8.

Figure 9-7

169

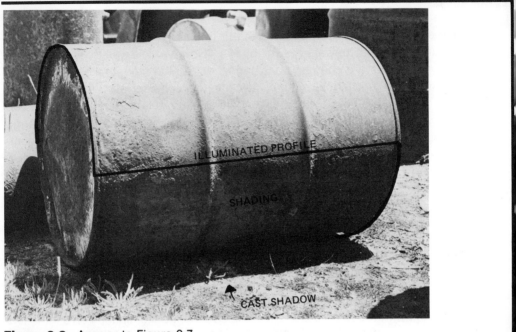

ILLUMINATED PROFILE

SHADING

CAST SHADOW

Figure 9-8 Answer to Figure 9-7

Determining Factors

1. *The shape of the form casting the shadow* determines the shape of the illuminated profile.
2. *The direction of the light source* in relation to the form and the viewer determines the location of the illuminated profile on the form, and the direction and length of the shadow.
3. *The shape of the surface on which the shadow falls:* the cast shadow takes the shape of the surface on which it falls.
4. *The nearness of the light source:* the closer the light source is to the form, the more the shadow will radiate from the form.

NATURAL LIGHT

Natural light is from the sun, and its rays are considered parallel.

Light Parallel to the Picture Plane

Vertical Dimensions When parallel light rays are also parallel to the picture plane, their direction may be thought of as indicated by a hand on a clock face that is parallel to the picture plane, with the hand somewhere between the nine and the three.

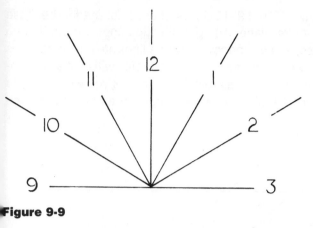

Figure 9-9

At any of these angles, a vertical form will cast a horizontal shadow. As the angle approaches a vertical position (or twelve on the clock), the shadow becomes shorter. Early morning and late afternoon sun produce the longest shadows.

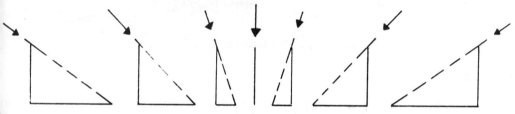

Figure 9-10

If the light direction is vertical (at the twelve o'clock position) the sun is at its zenith (directly overhead), and no shadow is cast unless by an overhang. Rarely is the sun seen at its zenith since this condition depends not only on time of day but also on season of the year and geographic location (fig. 9–11).

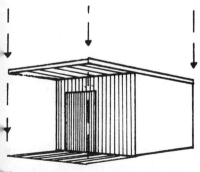

Figure 9-11

Casting a Horizontal Shadow Figure 9–12 shows a horizontal shadow because the light is parallel to the picture plane. All light direction lines are parallel no matter what angle you choose, and all shadow direction lines are horizontal. This means that a vertical from any point on the illuminated profile will cast a horizontal shadow from its base. You may cast as many verticals as you wish, but you *must* cast a vertical wherever the plane changes direction as it does at each corner of this box.

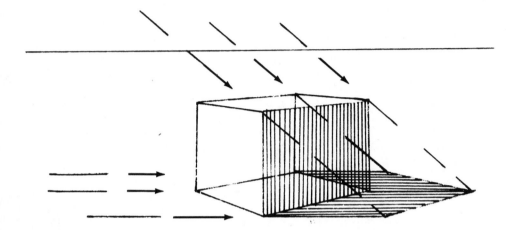

Figure 9-12

1. Draw a box in two-point perspective below eye level. Show hidden edges.
2. From the top of each vertical that is a corner on the illuminated profile draw a light direction line toward the ground plane.
3. From the base of each of these verticals draw a horizontal shadow direction line to intersect its light direction line.
4. Connect the points of intersection and return the shadow edge to the base on both sides of the illuminated profile.
5. Darken the cast shadow and the shaded sides by the box.

Checklist

1. Are all light direction lines parallel?
2. Are all shadow direction lines horizontal?

Now draw a box in one-point perspective with a horizontal shadow. Only one side will be shaded; darken it and the cast shadow. Use the checklist above.

Vertical Dimensions When parallel light rays are not parallel to the picture plane it is as though the clock face were tilted back or forward at the top or side, or both. Since parallel light rays are no longer parallel to the picture plane, they recede to or come from a vanishing point at the center of the sun. This is called the *light vanishing point (LVP)*. The light direction comes from this point through the top of any vertical dimension on the illuminated profile and continues to the surface as its cast shadow. To locate the point where it touches the surface another vanishing point is used. This is called the *vertical shadow vanishing point (VSVP)*. It is located on the horizon line (HL) vertically below or above the LVP. From the VSVP a line is drawn through the base of the vertical and continued to intersect the light direction, precisely establishing the length and direction of the shadow cast by the vertical. When the LVP and VSVP have been established for any one form, they should be the same for all forms and their shadows in the entire drawing.

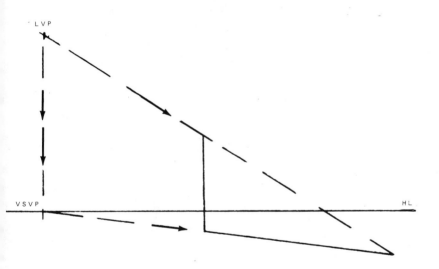

Figure 9-13

In figure 9–13 the shadow is cast forward. If the shadow is cast back, the vertical shadow vanishing point is on the shadow side, on the horizontal line, and the light vanishing point is vertically below it, as in figure 9–14. This does not mean that the sun is below the horizon line; it is the equivalent of the sun light coming from over your shoulder from the opposite side.

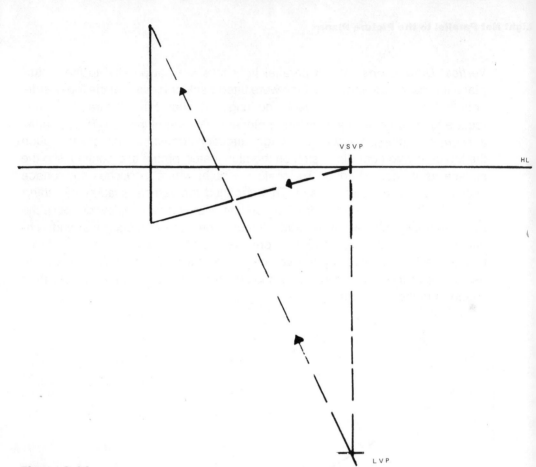

Figure 9-14

In these photos (figs. 9–15 and 9–16) is the vertical shadow vanishing point on the right or left? Is the light vanishing point above or below it? Answers are on page 176.

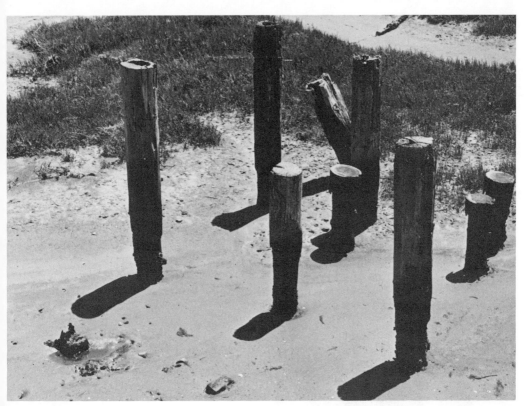

Figure 9-15

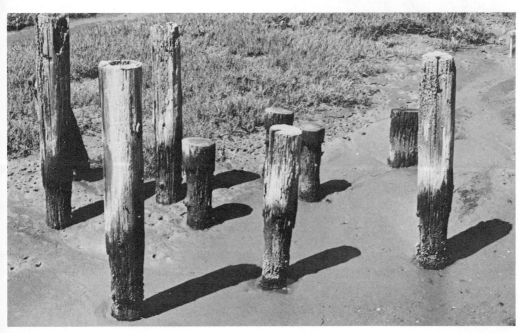

Figure 9-16

Horizontal Dimensions Horizontal dimensions on the illuminated profile (width and depth) cast shadows governed by the same vanishing points that govern these dimensions on the form: a nonreceding horizontal on the form will cast a nonreceding horizontal shadow; a receding horizontal will cast a shadow that recedes to the same vanishing point as this dimension on the form.

The Box

One Side Shaded The vertical shadow vanishing point and a vanishing point for the form are not often the same. If they are, on a box for instance, only one side of the box will be shaded. Figure 9–17 shows a trunk with one side shaded.

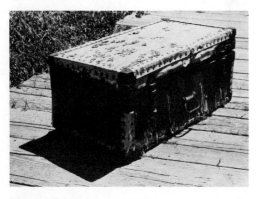

Figure 9-17

1. Draw a box below eye level in one point.
2. Place the LVP vertically above the VP.
3. The VSVP is now the same as the VP.
4. Draw the light direction line from the LVP through the top of each vertical and beyond.
5. Draw a shadow direction line from the VSVP through the base of each vertical and continue it to intersect the light direction line.
6. Connect the intersection points. This is the outline of the shadow. Any intersection points that fall inside the shadow area are not from the illuminated profile. Only one side of the box is shaded and casting a shadow. The horizontal on the illuminated profile casts a horizontal shadow.
7. Darken the shaded area and the cast shadow. Figure 9–18 is an example.

176

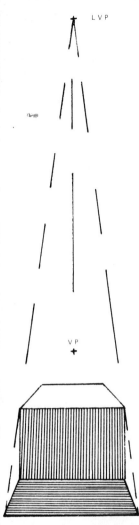

LVP

VP

Figure 9-18

1. Now draw a box below eye level in two point.
2. Place the LVP vertically above one of the VPs.
3. The VSVP is now on the selected VP.
4. Continue as before by drawing the light direction lines from the LVP through the top of each vertical and beyond.
5. Draw the shadow direction lines from the VSVP through the base of each vertical and continue it to intersect the light direction line.
6. Connect the intersection points and darken the shaded area and cast shadow. Again, only one side of the box is shaded.
7. The shadow cast by the receding horizontal on the illuminated profile recedes to the corresponding VP of the form. Figure 9–19 is an example.

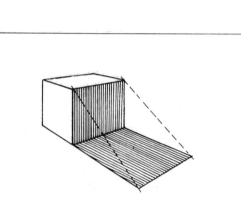

Figure 9-19

Two Sides Shaded Two sides will be shaded when the vertical shadow vanishing point is not on the vanishing point for the box.

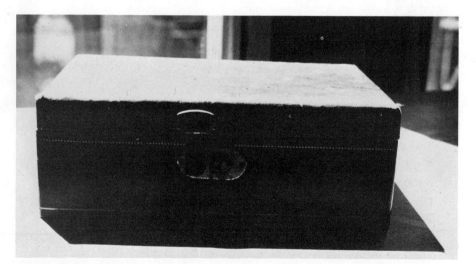

Figure 9-20

178

1. Draw a box in one point below eye level.
2. Place the VSVP on the HL but not on the VP.
3. Place the LVP vertically above it.
4. This shadow will be cast forward and to the side away from the LVP.
5. Two sides will be shaded, so three verticals will cast the shadow. Therefore it will be necessary to locate the base of the hidden back vertical on the shaded side.
6. Cast the shadow as before.
7. The receding horizontal shadow will go to the VP.
8. Darken the shaded area and the cast shadow. Figure 9–21 is an example.

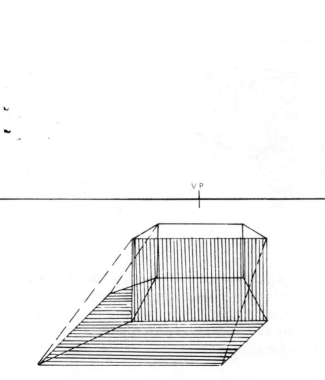

LVP

VP

VSVP

Figure 9-21

1. Now draw a box in two point below eye level.
2. Place the VSVP on the horizon line but not on a VP.
3. Place the LVP vertically above it.
4. The shadow will be cast forward and to the side away from the LVP.
5. Two sides will be shaded, so three verticals are required. Cast the shadow from all three.
6. The receding horizontals will cast shadows receding to the VPs.
7. Darken the shaded area and cast shadow. Figure 9–22 is an example.

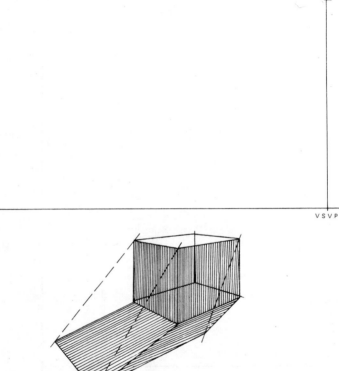

Figure 9-22

The Shadow Cast Back As mentioned earlier, when the shadow is cast back, the light vanishing point and vertical shadow vanishing point are on the shadow side. The vertical shadow vanishing point is on the horizon line, and the light vanishing point is vertically *below* it; the farther it is from the horizon line (whether above or below) the shorter the shadow will be. Figure 9–23 is an example.

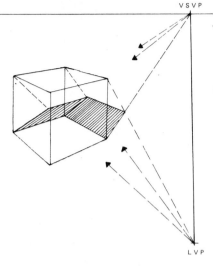

Figure 9-23

Draw a box in one point, two sides shaded, with the shadow cast back. Draw a box in two point, two sides shaded, with the shadow cast back. Remember to cast all verticals on the illuminated profile, even if they are hidden. Darken the shaded sides and cast shadows.

The Wedge When casting the shadow of the wedge, cast the two verticals, then connect them to the wedge base corner that has no vertical on the shaded side. Figures 9–24 and 9–25 are examples.

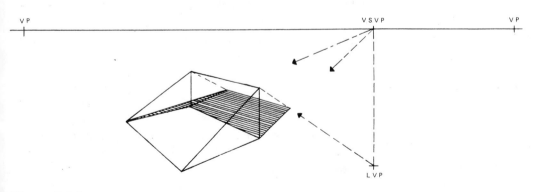

Figure 9-24

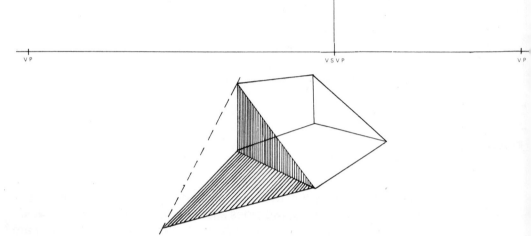

Figure 9-25

One Side Shaded You will see that it is possible to have only one side of the wedge shaded when the vertical shadow vanishing point is not on a vanishing point. This happens when one of the potentially shaded sides is the slanted top. Draw a wedge in one point with a horizontal shadow. Then draw a wedge in one point and a wedge in two point; cast the shadow back for one of them and forward for the other. Remember that the shadow direction is the direction cast by a vertical.

Shadows Cast on an Irregular Surface

When a shadow is cast on an irregular surface it follows the contour of that surface. The light direction lines remain constant, but the shadow direction lines change as the surface changes. To draw them, start at the base of the form casting the shadow. Here are some examples:

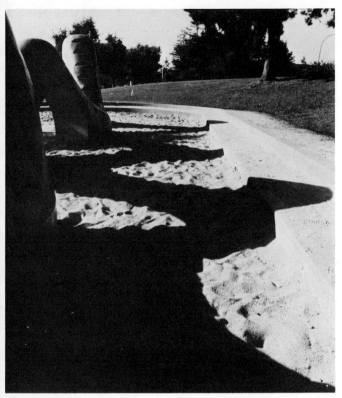

Figure 9-26

In figure 9–27 the building is casting a horizontal shadow on a vertical wall. The outlined continuation of the shadow shows where it would fall if the wall were not there. The shadow is drawn from the base of the building casting the shadow to the base of the wall, then vertically up until it intersects the light direction lines.

Figure 9-27

Drawn in the same way, the shadow in figure 9–28 is interrupted by a slanted plane.

Figure 9-28

Figure 9–29 shows an angled shadow cast on a vertical plane.

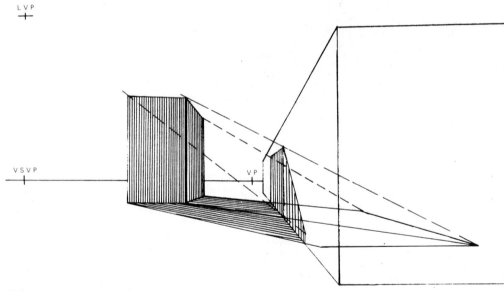

Figure 9-29

A horizontal shadow cast on a rounded surface is shown in figure 9–30.

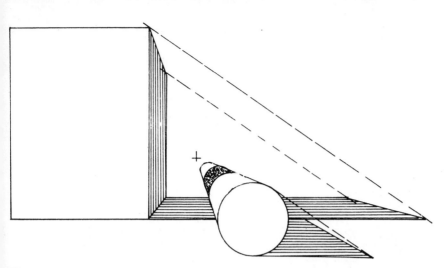

Figure 9-30

Figure 9–31 shows a shadow interrupted by a vertical plane not parallel to it.

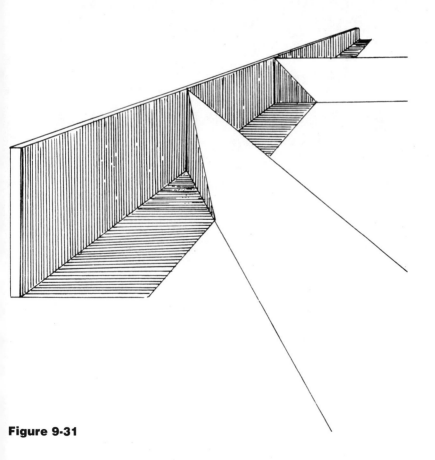

Figure 9-31

Now draw some of your own:

1. A horizontal shadow on a flat then vertical surface.
2. A horizontal shadow on a flat then slanted surface.
3. An angled shadow on a flat then vertical then flat surface.
4. A horizontal shadow on a flat surface that then goes down a steep slope, across a road, up a curb, and across a sidewalk.

Interior Shadows

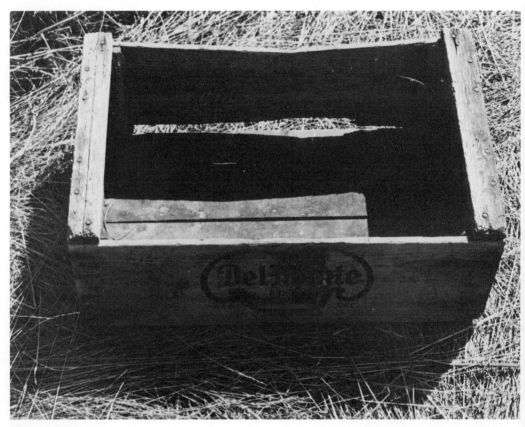

Figure 9-32

Shadows are cast on the interior of an open form in the same way as on any other irregular surface; the light direction remains the same, but the shadow direction changes as the surface changes. When you are unsure where the shadow falls, draw it first as though it were falling on a flat surface; the change in the surface direction is seen at the edge of the shadow. Draw an open box with interior shadow cast forward or back. Here are two examples:

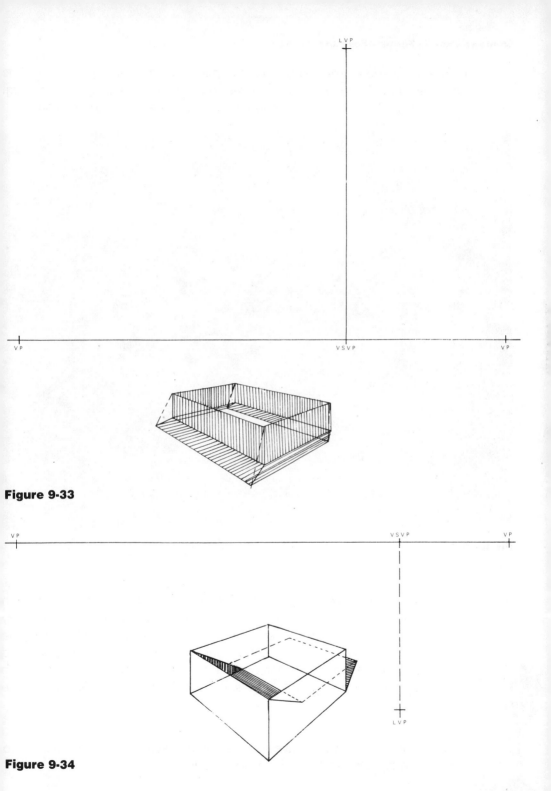

Figure 9-33

Figure 9-34

Shadows Cast by Forms Above the Surface

Frequently shadows are cast by a form or part of a form above the surface. This could be an overhanging branch of a tree, the eaves of a building, the cross arm of a power pole, a pedestal table top, or a ball on the surface or in midair.

Figure 9-35

In these instances the cast shadow can be very important in placing the form in space and clarifying its size and shape in relation to other forms. One very simple procedure will locate the shadow: *From the illuminated profile above the surface, draw a vertical to the point on the surface directly under it.* This is called a *base point.* The shadow can then be cast in the same way as other verticals in the drawing; use the base point on the surface as the base of the vertical. Figure 9–36 is an example.

Draw a simple bulding with eaves overhanging on at least one side. Shade two sides of the building and cast the shadow forward.

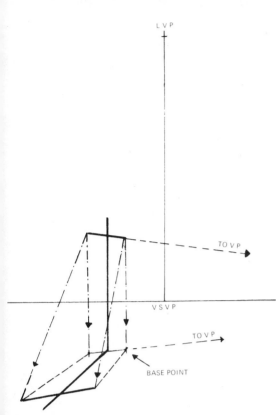

LVP

TO VP

VSVP

TO VP

BASE POINT

Figure 9-36

Shadows Cast by Cylindrical Forms

Figure 9-37

189

Natural light illuminates exactly half of the cylinder; therefore the illuminated profile runs the length of the cylinder on exactly opposite sides. These straight lengths cast shadow edges similar to the straight edges of a box. They are connected by the elliptical shadow edge cast by the round top.

The Cylinder on End To draw the ellipses of the standing cylinder accurately, draw the cylinder in a square-ended box seen in one-point perspective with the vanishing point vertically above its center (fig. 9–38).

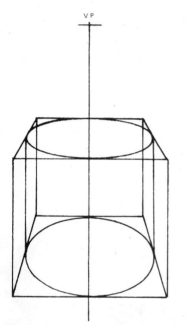

Figure 9-38

1. To cast the shadow, first locate either the LVP and VSVP or the illuminated profile, whichever is more convenient. The shadow direction is a line tangent to the base of the illuminated profile from the VSVP on the HL. The LVP is vertically above or below it (fig. 9–39).

2. Next, cast the shadow for the two vertical sides of the illuminated profile with a line from the LVP through the top of each vertical side intersecting a line from the VSVP through the base of each.

3. Now select several convenient points on the curved top of the illuminated profile and extend verticals to the base of the cylinder. Cast these additional verticals and connect their intersection points with a curving line. The shadow is outlined; darken it and shade the cylinder. Now draw a cylinder on end with shadow cast back. Then draw a cylinder on end with a horizontal shadow.

LVP

VSVP

Figure 9-39

The Cylinder on Its Side The cylinder on its side may be drawn freehand, or a template may be used for drawing the ellipses. This is the procedure for drawing a cylinder on its side using an ellipse template:

191

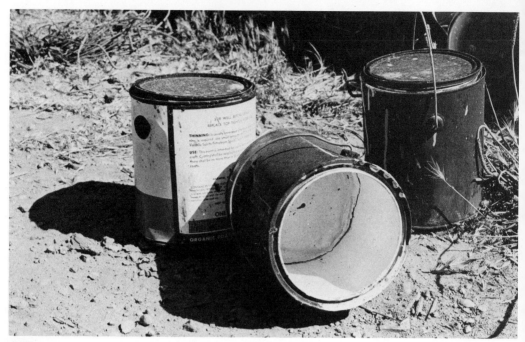

Figure 9-40

Using a Template

1. Measure if necessary to locate the center of the larger ellipse.
2. Place the VPs.
3. Draw a line from the ellipse center location to a VP. This will be the center core of the cylinder.
4. Draw a large ellipse with its short axis on the cylinder center core line.
5. Draw a line from the top and bottom of the long axis to the same VP.
6. Select a smaller ellipse of the same degree and place it so that it touches the top and bottom lines to the VP and its short axis is on the center line. The cylinder is complete (fig. 9–41).

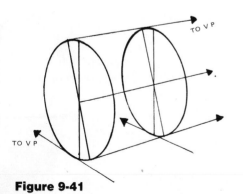

Figure 9-41

Casting the Shadow

1. Draw the cylinder on its side, making sure that the short axis of the ellipses are continuations of the center length of the cylinder.

2. Draw a vertical through each ellipse center to find the point where it touches the surface. This is *not* the long axis of the ellipse.

3. Through the touch point at each end draw a tangent to the ellipse and extend it to the VP. Base points for the ellipse will be on these lines vertically under selected points on the illuminated profile.

4. Locate the illuminated profile, VSVP, and LVP. Cast the shadow from conveniently established verticals along the illuminated profile (fig. 9–42).

5. Darken the shaded area and cast shadow (fig. 9–43).

L V P
+

V S V P

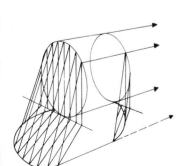

Figure 9-42

Figure 9-43

Draw a cylinder on its side with its shadow cast forward.
Draw a cylinder on its side with its shadow cast back.
Draw a cylinder on its side with its shadow cast horizontally.

The Open Cylinder When a standing cylinder is open, a shadow is cast inside it on the curved inner surface. The diameter establishing the illuminated profile is unchanged. Half of the top ellipse is the illuminated profile for the exterior shadow as before; the other half casts the interior shadow. To find the interior shadow:

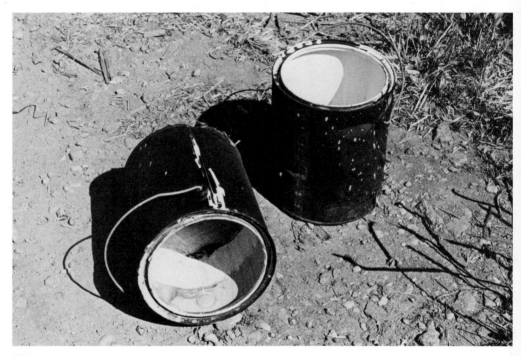

Figure 9-44

1. Select several convenient points on the illuminated profile that is the half ellipse closer to the light source (fig. 9–45).
2. Through each draw a shadow direction line from the VSVP and continue it to the opposite side of the rim.
3. From each of these points a line is drawn vertically down the side of the cylinder.
4. Draw a light direction line from the LVP through each point casting the shadow intersecting its corresponding vertical on the opposite side.
5. Connect the intersecting points with a curved line, bringing it to the top at the illuminated profile diameter.
6. Darken the shadow.

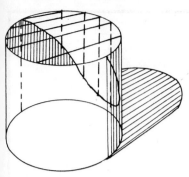

Figure 9-45

The same method is used for the cylinder in any position. Figure 9–46 shows several shaded cylinders. Draw their interior cast shadows. Answers are in figure 9–47.

V S V P
+

+
L V P

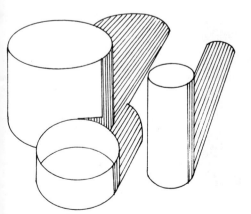

Figure 9-46

+

Figure 9-47 Answer to Figure 9-46

Shadows Cast by Cones

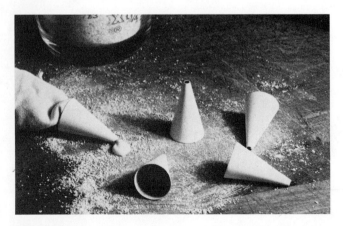

Figure 9-48

Cones cast a great variety of shadow shapes on a flat surface, according to their position and the light direction. The simplest of these shadows is cast by the cone on its base.

The Cone on Its Base When it is necessary to place the cone accurately in space it may be done as with the cylinder by drawing it in a square-ended box. The tip is at the center of one end. The cone has only one vertical through which to cast the light direction and the shadow direction; this is the vertical from the tip to the center of the base. To find its shadow:

1. Draw the cone and its illuminated profile, which is a straight line from tip to base. If the shadow is horizontal, the illuminated profile will be in the center; if the shadow is angled, it will be off center.
2. Locate the hidden base of the illuminated profile on the far side with a line from the base of the illuminated profile on the near side through the center of the base.
3. Locate the VSVP by drawing a tangent to the base of the illuminated profile and extending it back to the horizon line. The LVP is vertically above it.
4. Cast the shadow of the cone tip with a light direction line from the LVP through the tip and beyond, and a line from the VSVP through the center of the base to intersect it.
5. Connect this point with both sides of the illuminated profile at its base.
6. Darken the shadow (fig. 9–49).

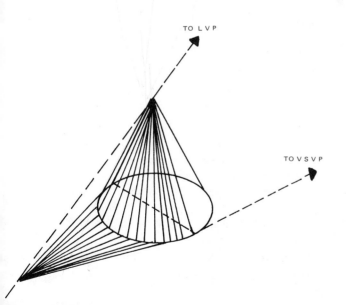

Figure 9-49

Draw the cone on its base with a horizontal shadow.
Draw the cone on its base with a shadow cast forward.
Draw the cone on its base with a shadow cast back.

The Cone on Its Tip To cast the shadow of the cone on its tip, proceed as with
the cone on its base, reversing its position. Now the ellipse of the cone casts a
shadow, so draw it the same way as the top ellipse of the cylinder. Base points
are located on a base ellipse vertically under the top rim.

Remember that the shadow direction is tangent to the illuminated profile at its
base point on the base ellipse. As with the cone on its base, the shadow direction
is not a shadow edge; the cast ellipse returns to the point of the cone on both
sides. Figure 9–50 is an example.

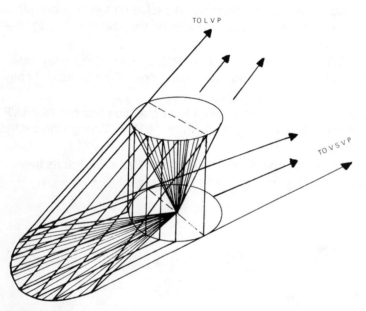

Figure 9-50

Draw a cone on its tip casting its shadow forward.
Draw a cone on its tip casting its shadow back.
Draw a cone on its tip casting a horizontal shadow.

The Cone on Its Side This is a difficult form to place accurately because the
face of the cone is not vertical in this position; it is slanted back at the top toward
the tip, at an angle equal to one-half of the angle at the cone tip (fig. 9–51). Seen
in side view it can be measured, but in other views the slant is usually estimated

Figure 9-51

If you prefer to calculate it exactly, draw the cone in a square-ended box in two-point perspective with its tip centered at one end. Then rotate on the contact point of the ellipse end and submerge the opposite end of the box halfway into the surface. The cone side is then touching the surface, and the face is at the correct angle. These are the steps to follow:

1. Draw a square-ended box in two-point perspective (fig. 9–52).

2. Draw a line through the center of both square ends and extend it to the VP. This is the cone center line.

3. The cone face ellipse touches all sides of one square end with its short axis on this line. The cone tip is at the center of the opposite end. Draw the cone.

4. Draw a line vertically under the cone center line to the same VP to locate the center length of the bottom of the box. This will be the *contact line* when the box is submerged and the cone length is touching the surface.

Figure 9-52

5. Draw a line from the cone face center through the new tip location on the contact line and extend this line to a slanted plane VP vertically under the eye level VP.

6. Redraw the cone face ellipse with its short axis on this line. Complete the re-positioned cone (fig. 9–53).

Figure 9-53

Casting the Shadow

1. To find the base point ellipse vertically under the now slanted face of the cone, first draw a line on the cone face from the contact line through the face center to the top, then draw verticals from the center and top to the contact line (fig. 9–54).

Figure 9-54

200

2. The base point ellipse center will be on the contact line vertically under the face center. To find its long axis, locate a slanted plane VP on the face side vertically above the eye level VP, as far above as its opposite is below its eye level VP. Draw a line from this raised VP through the base point ellipse center. The long axis is on this line. Its length is limited by verticals tangent to each side of the cone face.

3. Draw lines parallel to the long axis through the face contact point and the point on the contact line vertically under the face top. The short axis of the base point ellipse is limited by these lines.

4. Draw the base point ellipse.

5. Establish the LVP and VSVP and cast the shadow.

6. To find the illuminated profile on the length of the cone, cast the entire end. Then draw a line from the cone tip tangent to the shadow. Trace this tangent point to its source on the illuminated profile. Draw a line on the cone from this point to the tip.

7. Darken the shaded area and the cast shadow (fig. 9–55).

Figure 9-55

Draw a cone on its side below eye level with its shadow cast forward.
Draw a cone on its side below eye level with its shadow cast back.
Draw a cone on its side below eye level with its shadow cast horizontally.

Cone Sections A cone section, or tapered cylinder, is drawn in the same way as the cone except that its smaller end is a smaller circle, usually seen as an ellipse. To cast its shadow use the same method as for the cone.

Interior Cone Shadows A cone section is often open at one end or both; a paper cup is a good example. Often the open end casts a shadow on the cup's interior.

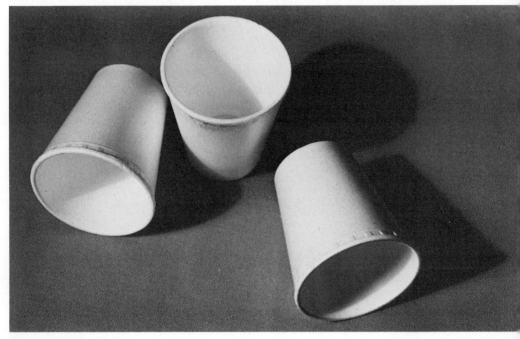

Figure 9-56

To find the interior shadow use the same principle as for shadows cast on other irregular surfaces: The light direction remains the same, but the shadow direction changes as the direction of the surface changes.

Draw a paper cup upright on a flat surface, casting its shadow back and to the right, and draw its interior shadow:

1. Start by drawing the bottom ellipse.
2. Over it draw a larger ellipse with both axes in common. The larger ellipse should have the same long axis as the top of the cup and will be the base point ellipse for the top of the cup vertically above it.
3. Draw a receding square around the large ellipse with a one-point VP centered above.
4. Vertically extend the corners of the square up and complete a box. Draw another ellipse on the top of the box and connect the top to the bottom of the cup on each side (fig. 9–57).

V P

Figure 9-57

5. Establish the LVP, VSVP, and the edge of the illuminated profile at the top.
6. Draw the illuminated profile down both sides of the cup toward a cone point centered below, stopping at the bottom of the cup (fig. 9–58).

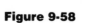

Figure 9-58

7. Cast the outside shadow in the same way as for the cone, returning the shadow to the base of the cup at the illuminated profile on each side (fig 9–59).

V P

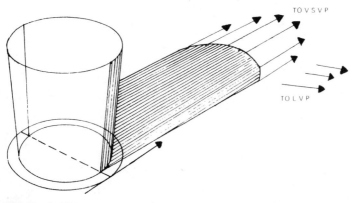

Figure 9-59

The interior shadow must agree with the exterior shadow; it is cast from the opposite side of the top illuminated profile. To find it (fig. 9–60):

1. Select several convenient points along the illuminated half of the top rim Project forward through each point from the VSVP to the opposite side of the rim, then down the side of the cup toward the cone point.
2. Then project a line from the LVP through each point into the cup to intersect the shadow direction on the opposite wall.
3. Connect the intersection points with a curved line, being sure to return to the illuminated profile at the top. Plot the entire shadow, though much of it may be hidden.

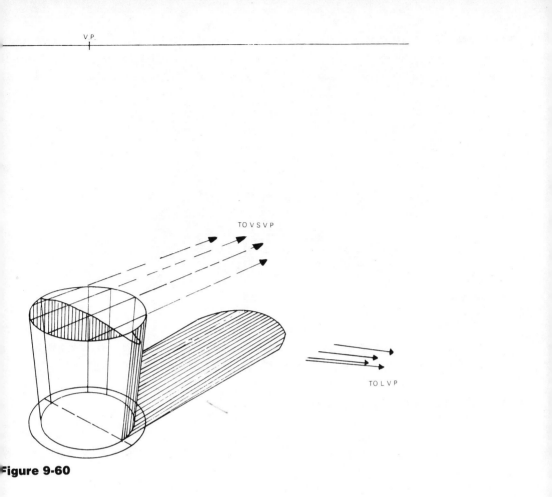

TO V S V P

TO L V P

Figure 9-60

This method may be used to plot the shadow of any open cone or cone section in any position.

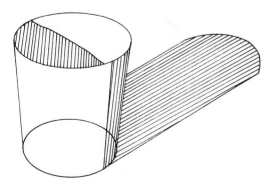

Figure 9-61

The Sphere

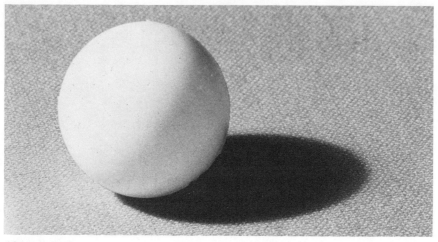

Figure 9-62

The sphere is seen as a circle from any view, so its shading and cast shadow are the principal clues to its three-dimensional form and to its position in space.

Locating the Sphere

1. Draw a circle and locate its center at the intersection of its vertical and horizontal diameters. The center of the sphere will be seen as the center of the circle from any position.
2. Locate the sphere in space by establishing eye level, VP centered above the sphere, and SP.

Shading the Sphere Exactly half of the sphere is shaded, so its illuminated profile is a circle, usually seen as an ellipse. It is seen as a straight line only when the light direction is parallel to the picture plane and when the circle center or an extension of it goes through the vanishing point; it is seen as a complete circle only when the sun is centered directly in front of it or behind it.

The short axis of the ellipse is on the light direction line; the long axis goes through the center at a right angle to the short axis.

1. Locate the LVP.
2. Draw a line from it through the center of the sphere.
3. Draw the ellipse with its short axis on this line. The ellipse is the illuminated profile. If the sun is coming from behind the sphere, the shadow is cast forward and you see more than half of the shadow; if the shadow is cast back, you see less than half of it (fig. 9–63).

Figure 9-63

Casting the Shadow To find the cast shadow it is first necessary to find the base points on the surface directly under the illuminated profile. These form an ellipse centered around the point where the sphere touches the surface, called the *touch point*. If the ellipse is airborne the base points will be on the surface directly under the sphere.

Locating the Touch Point

1. Draw a line from the SP to the sphere center.
2. Draw a second line from the center, below the first and at a right angle to it.
3. At the point where the second line intersects the sphere, draw a horizontal to the sphere's vertical diameter. This is the touch point (fig. 9–64).

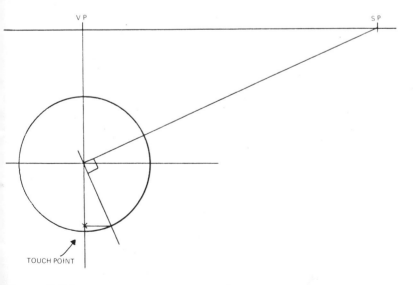

V P S P

TOUCH POINT

Figure 9-64

Locating the Base Point Ellipse (see fig. 9–65)

1. Draw a horizontal through the touch point. This will be the long axis of the base point ellipse.

2. To limit its length, draw verticals tangent to the outside limits of the ellipse at right and left and bring these down to the touch point horizontal.

3. To limit its depth, draw a line from the SP through the touch point and beyond.

4. Then from the top end of the short axis of the illuminated profile draw a vertical to the touch point horizontal then back to or forward from the VP to intersect the diagonal from the SP. Draw a horizontal at the intersection. The vertical distance between this horizontal and the touch point horizontal is half the short axis of the base point ellipse.

5. Draw the ellipse with vertical and horizontal axes.

Figure 9-65

Casting the Shadow (see fig. 9–66)

1. Select several convenient points on the illuminated profile and draw a vertical from each to its base point on the base point ellipse.

2. Through each selected point on the illuminated profile draw a line from the LVP and extend it beyond the sphere.

3. The VSVP is on the HL vertically under the LVP if the shadow is cast forward; if the shadow is cast back, it is on the HL and vertically over the LVP.

4. Draw a line from the VSVP through each selected base point and extend it beyond the sphere to intersect a corresponding line from the LVP. Remember to cast the back of the illuminated profile from the back of the base point ellipse, the front from the front.

5. Connect the intersection points with a curving line to establish the shadow.

6. Darken the shadow and shade the sphere.

L V P
+

VSVP

V P

S P

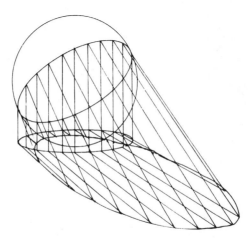

Figure 9-66

209

Now draw a sphere above the surface. Remember that the base point ellipse will be on the surface directly under the sphere, but the shadow will not be directly below unless the sun is at its zenith. The center of the base point ellipse is located where the touch point would be if the sphere were touching the surface. Draw the shadow so that no part of it is hidden by the sphere. Remember to keep the shadow within the 90 degree angle of vision to avoid distortion.

ARTIFICIAL LIGHT

Artificial light rays are not parallel; they radiate from a point at the center of the light source. The closer the light source is to the form casting the shadow, the more the shadow fans out from the form.

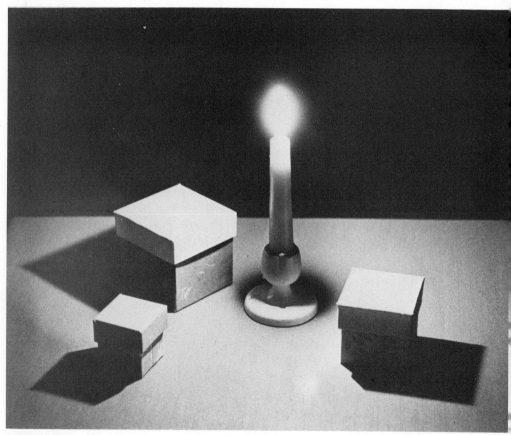

Figure 9-67

To draw the shadow cast by artificial light, the same method is used as for natural light except that:

1. The light source can be in any position, even below the form.
2. The VSVP is on the surface directly under the light source, not on the HL.

Placing the Light Source

The higher the light source is in relation to the form, the shorter the shadow will be. When the light source is below the top of the form, the shadow, or part of it, is cast up; it is clearly seen only on a surface opposite the light source—perhaps a wall or ceiling.

Placing the Vertical Shadow Vanishing Point

The vertical shadow vanishing point is vertically under the light vanishing point on the surface. A horizontal through it locates the light source distance in space: if it is in front of the form, the shadow is cast back; if it is in back of the form, the shadow is cast forward.

Casting the Shadow

Cast the shadow as previously:

1. From the LVP draw a line through the top of each vertical and extend it beyond.
2. From the VSVP draw a line through the base of each vertical to intersect the light direction line.
3. Connect these points to determine the shadow. When correctly drawn, all shadow edges cast by verticals of the form recede to the VSVP, and all shadow edges cast by horizontals of the form recede to the same VP as those of the form. This method is used for all forms.

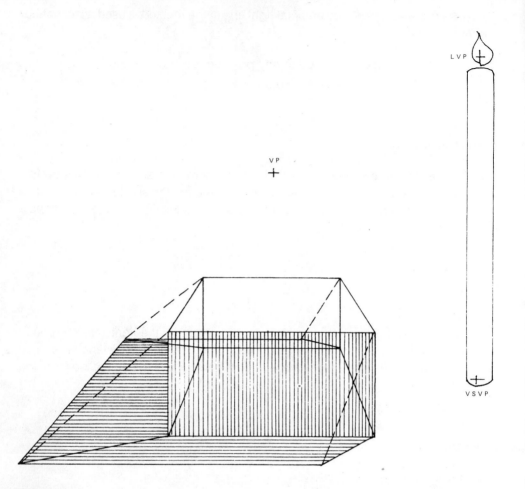

Figure 9-68

Draw several forms arranged around an artificial light source located above the tops of the forms. Darken their shaded sides and cast shadows. Now draw a box with an artificial light source below its top, casting its shadow on a wall. Darken shaded sides of the box and the cast shadow. Remember that when the shadow reaches the wall it changes its direction to the vertical of the wall. Figure 9–69 is an example.

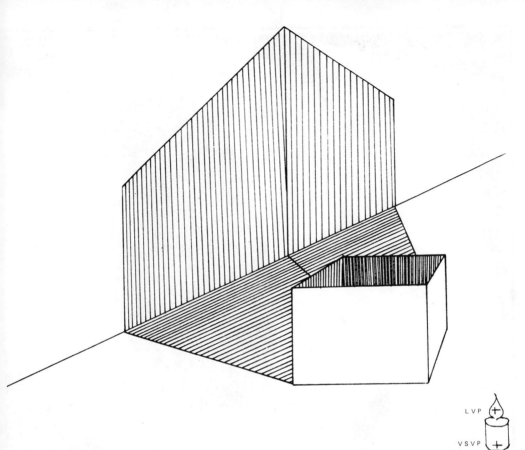

Figure 9-69

reflections

FUNCTIONS

Reflections add richness to visual perception by multiplying images, and sometimes by superimposing one image on another, as when a reflection on a window is superimposed on images seen through the window, or when an irregular reflecting surface reflects a distorted image (fig. 10–1).

Figure 10-1

In addition, reflections can add to visual information by revealing hidden forms or hidden parts of a form and by describing the texture and shape of the reflecting surface (fig. 10–2).

Figure 10-2

This is most obvious in water. When the surface is very still, undisturbed by wind or water currents, the reflection is clear and perfect; but if there is a ripple on the water the image is broken or distorted (fig. 10–3).

Figure 10-3

Highlights on curved surfaces are reflections of the light source, and if the surface is very smooth, as glass is, the image of the light source can be clearly seen; if the surface is textured the image is diffused. Reflections are usually included in a drawing or painting to reinforce the intent of the artist either compositionally or conceptually or both. The principles discussed here concern flat perpendicular reflecting surfaces only, but if you wish to pursue your study further, you will discover curved and angled reflecting surfaces too.

DRAWING REFLECTIONS

One principle governs pependicular reflections: The reflecting surface reveals a reversed image of the same size, at the same distance from the surface, and governed by the same vanishing points as the reflecting form.

IMAGES REFLECTED DOWN

Figure 10-4

1. Draw a child's alphabet block sitting on a flat surface. Draw it in one point showing the front, top, and one side.

2. The surface it is sitting on is a mirror; draw its reflected image. Measuring from surface contact points at the corners, draw edge lines straight down exactly as far as verticals go up. Receding edges will go to the eye level VP (fig. 10–5).

3. Draw a second block on top of the first one and draw its reflection.

V P

Figure 10-5

4. Erase the first block and its reflection and show the reflected bottom of the remaining block. This is the reflection you would see if the block were being held above the surface (fig. 10–6).

Figure 10-6

This method of calculating reflections applies to any form. Figures 10–7 and 10–8 show a pole sticking out of the water at a slant.

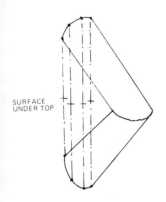

Figure 10-7
LEANING BACK

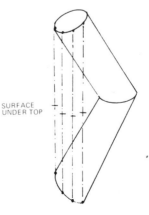

Figure 10-8
LEANING FORWARD

The same method is used in landscape. If the moon is reflected in the water, use the horizon line (eye level) as the surface contact point to place its reflection. Surface contact points for irregular forms (mountains, rocks) should be calcu- lated as points on a level surface directly under the visible profile. The closer the form, the farther below eye level the surface point would be. Close forms and their reflections sometimes hide reflections of forms farther away. The landscape in figure 10–9 shows how this works.

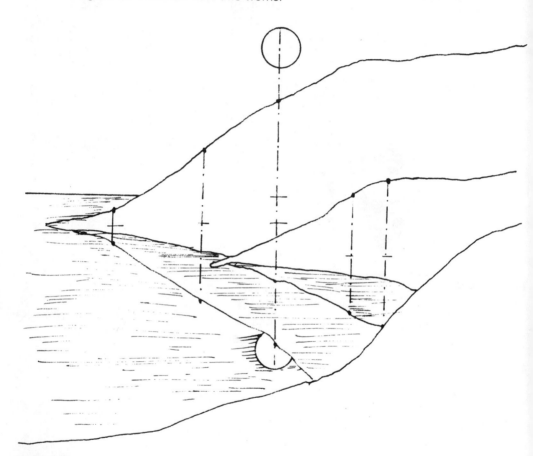

Figure 10-9

Draw a landscape of your own. Show some natural forms and some man-made forms reflected in water. Show a variety of distances with some reflections hid- den by other forms and their reflections.

Figure 10-10

When a reflecting surface is pependicular (at right angles) to the picture plane, the same method is used to find the reflection.

Draw an alphabet block in one point showing top, front, and one side. Draw a perpendicular mirror on the other side of the vanishing point and draw the reflection of the block in the mirror (fig. 10–11):

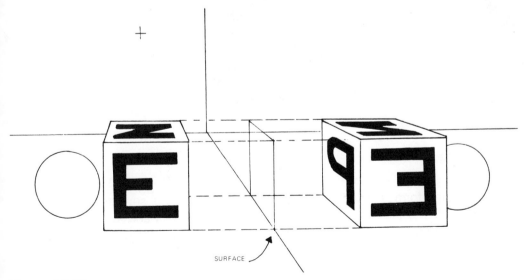

SURFACE

Figure 10-11

1. From each corner measure horizontally across to the mirror surface, then measure an equal distance on the other side. The receding edges of the reflected image will recede to the VP established for the block.
2. Now draw a ball smaller than the block and placed next to it away from the mirror. Judge its placement in the reflection by finding its point of contact with the surface, measuring from this point to the mirror, and repeating the measurement in the reflection. You may find that less of the ball is visible in the reflection.

IMAGES REFLECTED BACK

Figure 10-12

When a form is reflected back, the reflected image is smaller than the form; it recedes to the same vanishing point. The placement and size of the reflected image may be found by the same method used for a receding sidewalk (fig. 10–13).

1. Draw an alphabet block in one point touching a vertical mirror in back of it. Show the front, top, and one side; then draw its reflection.

2. Now draw a block moved forward so that it does not touch the mirror. Use the diagonal method for size and placement of the reflection. Show a letter on the reflected back side of the block.

3. Add a crayon or pencil lying at a diagonal near the block. This may be done by encasing it in a rectangle receding to the VP and continuing with the diagonal method used for the receding sidewalk.

Figure 10-13

MULTIPLE REFLECTIONS

Now draw a combination of reflecting surfaces showing a form or forms reflecting down, to the side, and back in the same drawing. Add shading and cast shadow.

You have drawn one-point, two-point, and three-point perspective, flat surfaces and slanted surfaces, with rectilinear forms aligned in a single direction or several directions. You have drawn circles, cones, and domes in perspective and have learned how to properly proportion and position objects and people in a drawing, their shadows and reflections.

Many drawings are done while viewing the subject, but the artist rarely makes an exact copy of what is seen—often it is a simplification or a rearrangement, and many drawings are done entirely from memory or imagination. In any of these cases, if you wish to present a convincing view of the visual world, these perspective drawing skills should help you.

Find a view of your world that excites you, and draw it. Draw the general shapes first, quickly and lightly. This will transmit your feeling. Then check your drawing for perspective accuracy, making corrections where needed. Remember to draw the correct line before erasing the incorrect line. Then bring your drawing to the desired degree of completion, taking care not to destroy the original feeling. Shading where appropriate will enhance the expression. The more you draw, the more you will enjoy it!

7377